KANSAS CITY
BEER

Pete Dulin

KANSAS CITY BEER

A History of Brewing
in the Heartland

PETE DULIN

AMERICAN PALATE

Published by American Palate
A Division of The History Press
Charleston, SC
www.historypress.net

Front cover, top: photograph by Roy Inman Photography.
Back cover, top: Jackson County Historical Society Archives; *bottom*: courtesy of Boulevard
Brewing Company.

First published 2016

Manufactured in the United States

ISBN 978.1.46713.561.0

Library of Congress Control Number: 2016941428

Contents

Preface

Carl Sandburg's poem "Happiness," published in his 1916 collection *Chicago Poems*, explores the meaning of happiness. Professors and famous executives are questioned first in the poem. They shake their heads and smile as though the person asking the question is a fool. The person seeking an answer then spends a Sunday afternoon along the Desplaines River, where a crowd of Hungarians has gathered under the trees with women, children, a keg of beer and an accordion. The poem ends without offering an explicit answer.

Sandburg's poem suggests that happiness involves gathering family and friends, sharing beer and music and spending time together. Beer may not bring happiness, but it can foster a social experience. With beer, we cheer crowning achievements and victories. We bond over tough times and bad news. Beer connects family, friends, co-workers and neighbors, fans of sports and the arts, people from all walks of life.

Like Sandburg's poem, *Kansas City Beer* involves a river and beer, but the connection is no coincidence or poetic observation. The Missouri River and the origin of Kansas City is less than a mile from my home in the River Market. I moved to the oldest section of Kansas City in mid-September 2015. Only a few months earlier, I began discussion with The History Press about writing a book on the history of brewing in my hometown. I lived within blocks of where the oldest breweries were established and the earliest settlers in the territory once lived.

Writing about Kansas City brewing from the 1850s to the present appealed to me for several reasons. *Kansas City Beer* expands on my previous book, *KC Ale Trail*, which profiled twenty-three craft breweries in Greater Kansas City and the surrounding area. Second, *Kansas City Beer* goes beyond the brewery history and memorabilia covered through 1989 in *Hometown Beer*, published by H. James Maxwell and Bob Sullivan Jr. Also, much has changed since Boulevard Brewing Company was founded in 1989. *Kansas City Beer* offers a contemporary, comprehensive look at the city's past and present breweries. Further, I included specific people, events and factors that provide historical context to these breweries.

History is ever-flowing like the water of the Missouri River. If we only focus on a ripple or moment, we miss seeing the grand, historic sweep of life passing downstream. The past is often taken for granted or forgotten. Yet history is always there like the river that wraps around Kansas City. *Kansas City Beer* explores a local brewing industry that continues to evolve.

While not a historian by trade, I have researched writings, documents and photographs; interviewed sources; and compiled the results. Any errors in the historical record are mine. Entries are organized by chronology based on the brewery's inception.

Records, individual recollections and written accounts of Kansas City's early beginnings, people and businesses are not complete. Some records and accounts conflict with others regarding dates and information. In some instances, these records (or their absence) complicate the definitive account of what happened and when beyond a doubt. In this book, I compiled a body of work about Kansas City's brewing history that hopefully won't further muddy the waters for future writers and historians.

Beer bottlers and brewery branches and depots not headquartered in Kansas City played a significant role in packaging and distribution. Names like Pabst Brewing may be familiar to readers. Brief mention will be given to operations that had a major presence. This book doesn't focus on brewery memorabilia. Further, I omitted brewpub chains owned out of state that have or had operations in Kansas City. *Kansas City Beer* highlights locally owned breweries that made beer in Kansas City from past to present.

My great-uncle on my grandmother Loretta's side of the family once worked at a brewery in Kansas City. The city's brewery and bottling operations once employed hundreds of people. Since Boulevard Brewing's launch, another generation has found work at hometown breweries and related fields. Additional breweries and taprooms in Kansas City indicate the promising future of the local beer industry and its growing workforce.

I remember gatherings at summer picnics held for and sponsored by a local Kansas chapter of the Veterans of Foreign Wars. My grandfather Edward Dulin, deceased, and father, Walter Dulin, are both veterans. Beer flowed from taps on delivery trucks at these picnics. Huge metal tubs were full of iced beer and whole watermelons. My siblings and I competed with other kids to see who could plunge their hands into icy waters the longest.

Sandburg's poem "Happiness" reverberates through this memory. Beer was part of that social backdrop, where family, friends and veterans passed time on a hot summer day in the Midwest. Today, the brewers of beer continue to play an intrinsic role in Kansas City's economy, community of fellowship and the making of memories.

Acknowledgements

Many people in Kansas City provided direct and indirect support and assistance in the creation of *Kansas City Beer*. The History Press initially approached Jay Aber of KC Beer Blog with its concept for a book on the history of Kansas City brewing. Unable to take on the project, Jay referred the publisher to me in the late summer of 2015. My research and writing began in earnest in the fall of 2015, working around the Kansas City Royals' thrilling post-season race to the 2015 World Series Championship. Commissioning editor Ben Gibson at The History Press kindly ushered me through the publishing house's process.

Thank you to archivists Caitlin Eckard of the Jackson County Historical Society, Anne E. Cox of the State Historical Society of Missouri and senior special collections librarian Jeremy Drouin of the Kansas City Public Library for assistance with obtaining historic images.

Special thanks to Julie Weeks of Boulevard Brewing Company, who supplied historical images of the brewery, provided ongoing assistance and arranged interviews with brewery founder John McDonald, Steven Pauwels, Jeremy Ragonese and Payton Kelly. Thanks to John and the Boulevard Brewing family for all that you've done for Kansas City.

Andy Rieger of distillery J. Rieger & Co. shared helpful documentation about the history of the Ferd. Heim Brewing Company. River Market Brewing Company and Power Plant Restaurant and Brewery owner Steve Palmer shared insight into these former breweries. Brewmaster/COO Junghoon Yoon of Platinum Brewing Company in Korea dredged up details

on his time with Pony Express Brewing. Brewer Robert Dewar provided notes on Mill Creek Brewing Company. Other people who contributed tips, leads and information include Susan Marks Miller, Mark Frazier, Lisa Markley, John Bryan, Neil Witte of Boulevard Brewing and Kyle Kelly. My gratitude extends to the many other brewers and owners—far too many to name here—who answered questions and fulfilled my requests.

My friend, occasional collaborator and fine photographer Roy Inman provided the cover image for *Kansas City Beer*. Thanks to photographer Paul Andrews for the author photo and photographer William Hess for use of his images.

A salute goes to the Beer Tasting KC community for their support of craft beer, breweries and one another. I'm proud to be part of the local beer community and can't thank you enough for your support and encouragement.

Thanks to Barbara Rafael, Mano Rafael, Judy Bayer Roth and my restaurant family at Le Fou Frog and many friends in the hospitality industry for much-needed food, drink, conversation and kindness on too many occasions to count. Brewers, brewery staff and bartenders throughout the industry deserve my thanks as well for the beers, insight, laughter and support. Of course, my gratitude extends to everyone who purchased and read my books. I apologize to anyone whom I neglected to name and thank in detail. Please remind me over a beer.

The expansive music of Scott Easterday and his band Expassionates at Davey's Uptown Ramblers Club inspired thoughts about the introduction to this book on a cool evening in October 2015. The timing of the band's show at The Ship in March 2016 coincidentally aligned with the book's conclusion.

Thank you to my family for their love and support, especially to my brother Steve Dulin for all that you gave us.

As always, please drink responsibly. Help others. Be kind. Live long.

Thank you, Kansas City.

Introduction

The Missouri River drew explorers and entrepreneurs to establish farms and settlements that preceded Kansas City, Missouri. Brewers, drawn by the lure of fresh opportunity, traveled west on the river to ply their craft nearly two decades after the city was founded. Innately, the history of Kansas City's earliest breweries is embedded within the context of the city's history. Both were intrinsically dependent on and connected by water, an essential ingredient in beer, along with hops, grain and yeast.

Kansas City's roots began near a natural bend as the river wound across grassy plains and carved past limestone bluffs on its journey east. French fur trappers and traders once used nearby rock ledges as river landings. Here, natural resources, promising possibilities and points farther west fed dreams and ambition.

Explorers, traders and pioneers came to the region once settled and occupied by the Kaw Nation, Osage Nation and other tribes. Meriwether Lewis and William Clark and their expedition traveled by water westbound from St. Louis, tracing a route previously traveled by the French. Lewis and Clark arrived at Kaw Point, near the confluence of the Kansas and Missouri Rivers, on June 26, 1804, and stayed for three days before continuing their journey.

François G. Chouteau and his cousin Gabriel S. Sères established a trading post in 1822 for the American Fur Co. on Randolph Bluffs. The post was based along the north bank of the Missouri River near today's Chouteau Bridge. Floodwaters in 1826 destroyed Chouteau's warehouse

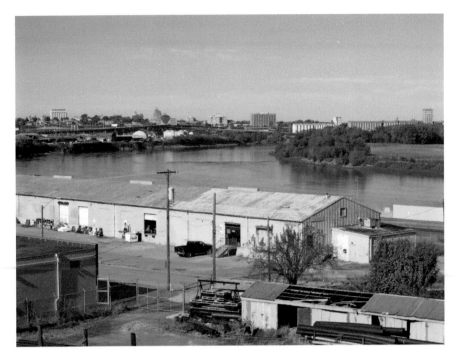

Kaw Point extends from the Missouri River bend on the right, facing Kansas City's West Bottoms on the opposite bank. *Photograph by Pete Dulin.*

and other structures. He moved west and rebuilt an outpost on the south side of the river on higher ground a few blocks away from what became Harrison and Gillis Streets. Chouteau's Landing attracted more traders, trappers, farmers and families. A French-speaking community formed around this trading post and surrounding farmland. Another flood in 1844 destroyed development along the river bottom. This second trading post was near the future birthplace of Kansas City and its City Market at Fifth and Grand.

Over a twenty-five-year span beginning in 1825, leaders of more than twenty-five Native American tribes were pressured to sign treaties that resulted in removal of tribes from the eastern United States to the territory that would become Kansas. These tribes included the Delaware, Iowa, Kanza, Shawnee and Wyandotte. They brought buying power and opportunities for trade to the Kansas and Missouri Rivers and surrounding plains.

In 1831, Reverend Isaac McCoy, a Baptist missionary ministering to tribes in the region, moved with his wife, Christiana, and family to a town site located four miles south of the Missouri River. His twenty-two-year-old

son John Calvin McCoy built a two-story log building by 1833 that served as a home and trading post at Westport Road and Pennsylvania. Today, a historic plaque on the side of a building at 435 Westport Road, where Beer Kitchen is located, identifies the area near McCoy's trading post. Across the street, the famous Harris House Hotel once stood on the property now occupied by a brewpub, McCoy's Public House. McCoy's post traded with trappers, Native Americans, farmers and pioneers headed west on the Santa Fe, California and Oregon Trails.

John McCoy cut a four-mile pathway through dense brush from his store to Westport Landing, a prominent limestone ledge on the Missouri River and between the foot of what is now Delaware Street and Grand Avenue. The steamboat *John Hancock* was the first to dock at Westport Landing with goods for McCoy's trading post. In 1834, McCoy purchased land and platted the town of West Port. He also became postmaster of the post office established in May of that year. By 1849, West Port had about ten stores, several blacksmith shops, a wagon maker's shop, three hotels and other businesses. The township was formally incorporated in 1857 as Westport.

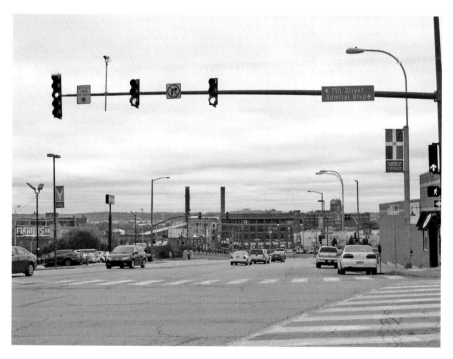

Grand Avenue and Seventh Street, facing north toward the River Market. John McCoy cut a pathway in the 1830s near this once-wooded limestone bluff to reach Westport Landing on the Missouri River. *Photograph by Pete Dulin.*

McCoy later became one of the fourteen founders of the Town of Kansas, the predecessor to Kansas City. Initially platted as 15 acres by McCoy, the town was built on the 257-acre farm estate of Gabriel Prudhomme, who died in a brawl in 1831. The estate, purchased for $4,220, included today's River Market roughly from Broadway to Holmes and from the river bottoms south to Fifth Street. When it was incorporated by the state in 1853, the town became the City of Kansas. Local residents referred to it as the more colloquial Kansas City. In 1889, it officially became known as Kansas City.

Easterners and waves of European immigrants journeyed west past St. Louis, many passing through or settling in Westport and Kansas City. The towns slowly grew in size and importance as trade and commercial interests converged. Meanwhile, the brewing industry remained concentrated in eastern states, St. Louis and the upper Midwest.

English and Dutch brewers influenced early American colonial brewing. Brewed with top-fermenting yeasts, British-style ales, porters and stouts were predominant. Breweries prospered in Philadelphia and other fast-growing cities in the East. However, production and consumption of beer remained mostly tied to local markets. Beer was perishable and expensive to bottle. Reliable cross-country transportation had not yet evolved to deliver beer in wooden kegs. Hundreds of small-scale breweries opened and prospered in their communities during the 1840s and 1850s. Brewing in Kansas City wouldn't begin for nearly another decade.

As rough-and-tumble Westport and Kansas City found their footing, saloons played a prominent role in these communities. Notably, whiskey was more abundant at the time than beer. Author Francis Parker Jr., a lodge guest at the Harris House in 1846, wrote in *The Oregon Trail*: "Whiskey circulates more freely in Westport than is altogether safe in a place where every man carries a loaded pistol in his pocket."

Father Bernard Donnelly, who had visited Westport Landing as early as 1845, was permanently transferred in 1857 from Independence, Missouri, to Kansas City. He commissioned the building of a brick church between Eleventh and Twelfth Streets, west of Broadway. Father Donnelly also placed newspaper advertisements in 1858–59 that drew three hundred Irish laborers from New York and Boston. Donnelly sought to increase the size of his parish. To do so, he recruited Irish-born stonemasons, bricklayers and tradesmen to help construct the town's roads, avenues and buildings from its limestone bluffs. The north–south widening of gullies and excavations of Delaware (named after the tribe), Main, Broadway and other streets further connected Westport Landing and Kansas City to the

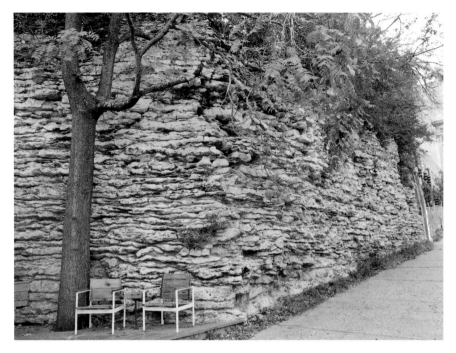

Tall limestone bluffs near Anthony's Restaurant at Seventh Street and Grand Avenue. Irish immigrants in the late 1850s–'60s cut roadways through these bluffs to reach the riverfront. *Photograph by Pete Dulin.*

growing Westport community. By agreement, Irish laborers had to abstain from liquor as part of the deal to secure jobs and lodging in their new home. As newly improved roadways replaced dirt thoroughfares and rocky bluffs, the city took shape.

German immigrants began migrating in the 1840s across Missouri from St. Louis and points farther east. These immigrants brought with them not only a cultural tradition of brewing and beer drinking but also new brewing technology and styles. Lagers and pilsners grew in national popularity, rivaling the brewing and consumption of ales and porters. Imported beer from the East was more readily available at saloons. Commercial brewing in Kansas City—still resembling a frontier town rather than the more established city of St. Louis—did not commence until the mid- to late 1850s, perhaps because of the regional tumult of the era.

During the 1850s, the nation entered a simmering period of tension and internal conflict that pitted proslavery and free states against one another. Senator Stephen Douglas introduced the Kansas-Nebraska Act in 1854

before Congress. The bill called for the territorial organization of Kansas and Nebraska. As part of the act, the issue of slavery was to be decided by popular sovereignty. This proposition fomented tensions between occupants of the Kansas territory, specifically Lawrence, and western Missourians. Northern abolitionists organized groups for the settlement of Kansas Territory to oppose western Missourians who were predominantly proslavery. This tension led to Bleeding Kansas, or the Kansas-Missouri Border War. Violent fighting and raids ensued between antislavery settlers known as Jayhawkers and Missouri's Border Ruffians.

Amidst this chaos in 1854 and after, settlers streamed into Westport and Kansas City bound for the Kansas Territory and beyond. Between 1855 and 1857, the Gillis House Hotel near the river reported twenty-seven thousand new arrivals. In Rick Montgomery's essay, "Foreword on the Civil War in Kansas City," published in the *Kansas City Star*, he writes:

> *For settlers headed to Kansas or further west along the California, Santa Fe, or Oregon Trails, the westernmost railroad only extended to St. Joseph. Many settlers traveled from there on the Missouri River and arrived at the Town of Kansas, or "Westport's Landing" at the confluence of the Kansas and Missouri Rivers, where the founders of the future Kansas City hoped to benefit from traffic heading west.*
>
> *Passers-through quickly noted that the more established outfitting village of Westport, to the south, was a "hot bed" of proslavery types, where at times "no Free State man was safe in passing," as one visitor wrote.*
>
> *In the center of the chaos sat upstart Kansas City. Its population ticked toward 4,500 in the late 1850s despite the bleeding in Kansas and the stealing out of Missouri. Town officials of Northern and Southern backgrounds welcomed more than 700 steamboats unloading at the levee in 1857.*

These turbulent developments lent uncertainty to trade, settlement and business investment as Kansas City grew out of its infancy. During the Border War, the city's trade was described as "all energy and enterprise dead." Further, these confrontations preceded the American Civil War (1861–65) and, locally, the Battle of Westport in 1864. Once this disruptive period subsided, Kansas City worked toward economic, social and political recovery, and its fortunes steadily improved.

Within a span of thirty years, Kansas City and Westport arose from rock ledge landings and trading posts to frontier towns. Limestone bluffs

and gullies transformed into streets, markets and homes. The towns served as nineteenth-century hubs for westbound travelers. Immigrant Irish, Germans and settlers from the eastern United States chose to remain and establish roots.

Kansas City's population swelled as a successive stream of people arrived. Community and commerce formed against a volatile backdrop of territorial disputes, bloodshed, war and slavery. Despite the turmoil, people saw promise in the future of Kansas City. Investments funded opportunities, labor fueled progress and ambition fed nascent hopes for businesses that included the brewing and selling of beer.

Chapter 1

Early Brewing in Kansas City

A walk east along Third Street behind the City Market leads past the River Market North stop on the Kansas City Streetcar line. Asphalt on side streets covers brick cobblestones and layers of dirt, rock and limestone bedrock far below. The Metrobus line stops at Third and Grand Streets, where passengers board and take the 103, 110 or 142 routes. Today, the densely populated River Market neighborhood could pack a brewery's taproom within walking distance of home and work. Roughly 160 years ago, Kansas City's first known brewery was located one block east at Third and Oak and served the city's growing populace.

Kansas City's population grew from 700 residents in 1846 to 5,185 people by the end of 1857. The city had two unidentified breweries, based on records cited in C.C. Spalding's *Annals of the City of Kansas and the Great Western Plains.*

By comparison, St. Louis was home to twenty-four breweries by 1854 and reached forty breweries six years later with a collective annual output of 189,400 gallons of beer. These breweries employed hundreds of German immigrants, beer gardens flourished and lager became the emerging beer style of choice. To the west, brewing in Kansas City would not fully get underway until the mid- to late 1850s.

1842: WESTON BREWING COMPANY, ROYAL BREWING COMPANY

Touting itself as the "oldest brewery west of the Hudson River," Weston Brewing Company (500 Welt Street, Weston, westonirish.com) was founded in 1842 by German immigrant John Georgian north of Kansas City. The brewery used ice from the Missouri River during winter to fill four stone cellars and chill solid oak lagering tanks. These conditions enabled storage below sixty degrees for more than six weeks. Weston Brewing became one of the first lager breweries in the United States. The cellars are still used today.

After Georgian died in 1857, August Kunz of Leavenworth, Kansas, acquired the brewery. The Kunz family ran a brewery in Leavenworth around the same time as Georgian. When a fire destroyed the Weston brewery in 1860, Kunz rebuilt it and continued operations. Twelve years later, financial problems forced Kunz to close the brewery.

English immigrant, engineer and Leavenworth brewer John Brandon teamed with fellow Leavenworth resident George Mack in 1885 to reopen the brewery. Two years later, Brandon and Mack negotiated a deal with Lawrence brewer John Walruff, who acquired the brewery with his son. Walruff also operated a large brewery and beer garden in Lawrence, Kansas.

Kansas passed a prohibition law in 1880 that led to a shutdown of the state's breweries. Walruff spent six years and thousands of dollars trying to circumvent the law by claiming his products were "medicinal beer" that cured various ailments. An 1887 Supreme Court decision against Salina, Kansas brewer Peter Mugler and the United States Brewers' Association affirmed a state's right to close down a brewery if the state deemed it would prevent injurious use of its product. That court decision prompted Walruff to relocate his brewery to Weston, where the hand of the state did not intrude as deep into a brewer's affairs.

Walruff and son August spent $50,000 and overhauled the brewery. Under the reign of August, the brewery made twelve thousand barrels of pale lager annually. Between 1887 and 1907, the brewery changed ownership and incorporation twice. By the early 1900s, the brewery was the largest manufacturing plant in Platte County and annually produced twenty thousand barrels.

Weston Brewing's branch offices were located at Fifteenth and Hickory Streets in Kansas City and 319 Shawnee at the Leavenworth depot. In 1901, a new corporation was formed called the Royal Brewing Co. of Kansas City.

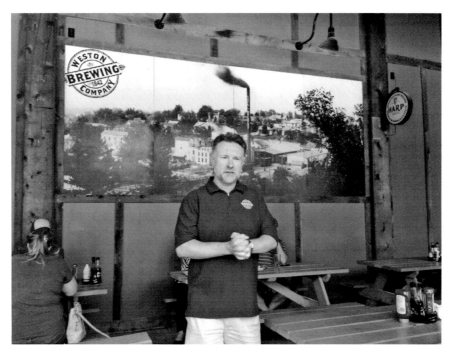

Weston Brewing Company co-owner Michael Coakley stands before an image of the mid-nineteenth-century brewery, once known as Royal Brewing Company, as the smokestack indicates. *Photograph by Pete Dulin.*

A branch office was established at 1111–14 Grand Avenue in Kansas City. In 1904, it moved to 1912 Grand Avenue. The Kansas City branch office was moved to 308 West Sixth Street and later to 310 West Sixth Street. The brewery closed with the onset of Prohibition (1920–33).

Under new ownership from 1997 to 1999, Weston Brewing Company operated a twenty-four-barrel traditional brewing operation located next to the original stone walls of the Royal brewery. It produced Weston Pale Lager and Irish Ale true to original nineteenth-century beer styles. The former minority owner and brewer closed the brewery for unspecified reasons, laid off employees and left the brewhouse intact. The property remained dormant for years.

Meanwhile, homebrewers Corey Weinfurt and Michael Coakley, childhood friends since the ages of five and six, dreamed of owning and operating a brewery. They homebrewed together in college. Post-college, Coakley worked as a server at River Market Brewing Company in Kansas City during the mid-1990s and advanced to management. He helped to

open Power Plant Restaurant and Brewery in Parkville and stayed for two years before returning to college to complete a master's degree.

Circa 2003–4, Weinfurt called Coakley when the previous owner of Weston Brewing closed shop. They initiated discussions with property owner Pat O'Malley about leasing the space. A deal with a five-year lease was struck with O'Malley, and Weston Brewing Company was reborn under new ownership.

"In May 2005, there was still beer in the tanks that was brewed in 1999," Coakley said. "It took two years to refurbish the brewery and replace motors, pumps, plastic, and rubber seals."

Weinfurt and Coakley not only bought the brewery, but they also acquired O'Malley's Pub and America Bowman Restaurant located on the premises. By 2012, they discontinued leasing the property and bought the real estate from O'Malley. The brewhouse is equipped with a twenty-five-barrel brew kettle, two fifty-barrel fermenters and eight fermenters that range between twenty-five and thirty-five barrels. Annual volume fluctuates around eight thousand barrels.

Top-selling brands include O'Malley's Cream Ale and English Bitter–style Drop Kick Ale. The brewery also makes O'Malley's Stout, O'Malley's IPA,

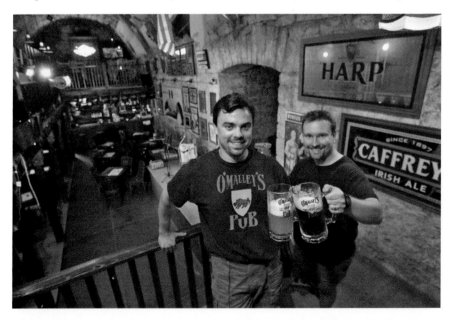

Weston Brewing Company co-owners Corey Weinfurt (*left*) and Michael Coakley stand in O'Malley's Pub located in an underground cellar by the brewery. *Courtesy of Weston Brewing Company.*

Emerald Lager and seasonal Leapin' Leprechaun Ale. Weston Brewing has a 25 percent ownership stake in Root Sellers Brewing Company, launched in 2015, which produces and sells alcoholic Row Hard Root Beer, Pedal Hard Ginger Beer and Hard Cream Soda. Root Sellers' production is split between Weston Brewing and Root Sellers' base in Columbia, Missouri.

At one point, Weston Brewing was a contract brewer for Cathedral Square Brewing in St. Louis for two years and Flying Monkey Brewing Company in Olathe, Kansas. In 2009, Weston Brewing acquired Flying Monkey and continues to brew several of its brands. Weston Brewing's products are distributed in twenty states across the United States, but the bulk of distribution is concentrated in Missouri and Kansas.

Around 2013, Weston Brewing converted to only packaging in cans. Sunlight is unable to enter cans and potentially affect its contents. Cans are also much lighter to ship and easier to recycle than bottles, making them cost-effective and environmentally sustainable.

Weston Brewing offers tours on Saturdays. The one-hour walking tour covers the brewery's fascinating history, includes a walk-through of the brewery and underground cellars and concludes with a tasting of a flight of beers in O'Malley's Pub. The original stone walls of Royal Brewery are still visible as a reminder of the brewery's vivid history.

LATE 1850s: KANSAS CITY BREWERY, THIRD STREET BREWERY

Peter John Schwitzgebel opened the oldest known brewery in Kansas City sometime in the late 1850s. Schwitzgebel, a native of Germany, and his wife, Wilhelmina, moved from St. Louis to Kansas City in 1855. By 1860, he operated Kansas City Brewery at the corner of Third and Oak Streets near the East Levee. Schwitzgebel placed an advertisement in the *Kansas City Daily Journal* dated August 8, 1865, that boldly declared, "I am prepared to furnish the public with the best lager beer made west of St. Louis; also white beer, ale, and porter," having "secured the services of a Pittsburg brewer." By 1869, the business was called Third Street Brewery.

The 1870 *Kansas City Business Directory* recorded that by the end of the previous year, proprietor "Peter Schwitzgable [*sic*]" had manufactured five thousand barrels of beer, valued at $65,000, and employed eight workers. The entry stated, "This brewery is the oldest in the city, its lager is famous

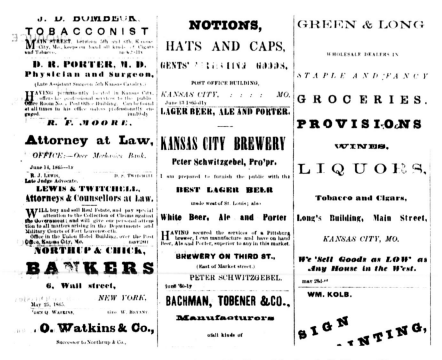

An advertisement in the *Kansas City Daily Journal* for Peter Schwitzgebel's Kansas City Brewery, circa 1865. *Courtesy of the State Historical Society of Missouri.*

for its fine flavor and rich taste. It stands in high reputation among the connoisseurs of this agreeable beverage."

According to a report in the *Daily Journal of Commerce* of Kansas City dated February 26, 1870, Schwitzgebel employed ten men and three wagons. He had about $50,000 invested in the brewery, which had a capacity of forty-five barrels per day, one-third of which was consumed in the city. The daily production capacity of the expanded brewery's malt house was one hundred bushels. The same issue of the journal lists an advertisement for P. Schwitzgebel, Proprietor of Kansas City Brewery, for beer and lager.

In 1871, Schwitzgebel changed the brewery's name back to Kansas City Brewery. He lost his property in 1872 in advance of the Panic of 1873. This national financial crisis was instigated when Jay Cooke and Co., a banking firm that led U.S. government investment in railroad construction, closed its doors on September 18, 1873. Schwitzgebel's loss was one of many casualties as a major economic panic swept the United States. The brewery's listing in the 1875 city directory shows a name change to Kansas City Brewing Company with Clark and Kump as proprietors.

Circa 1857: William Parish, James Hyatt McGee and John Tras

William Parish built a mill near the modern area of Thirty-third Street and Cleveland Avenue. He partnered with James Hyatt McGee, who operated a brewery and distillery in Westport near the area of Roanoke and the Allen School. McGee, one of the original fourteen founders of Kansas City, amassed a huge swath of property beyond the city's existing limits to the south. Known as McGee's Addition, this area was platted and built into homes, schools, churches and businesses. McGee also operated a gristmill and ferry, among other holdings. The property that housed the brewery and distillery was later sold.

Also, John Tras operated a brewery and saloon in Westport during this period, according to *Hometown Beer*. No other information is available on his business.

1859-60: Kansas City's Population Booms Before the Civil War

Kansas City's commercial trade expanded as the city's population swelled. Residency reached nearly eight thousand people in 1859 before dipping to six thousand as a result of tensions in the Kansas-Missouri Border War and approaching Civil War (1861–65). Advertisements in the city directory appeared for businesses in St. Louis, Indianapolis, Cincinnati, Kansas City and a growing number of railroads, all seeking the attention and trade of this thriving Midwest city.

Occupations of the city's residents included painter, glazier, lightning rod peddler, bar-tender, brick maker, attorney, saddler, tinner, physician, tailor, stage driver, seamstress, stonemason, bookkeeper, cistern builder, carpenter and more. Business owners, workers and visitors to the city patronized twenty-two saloons and three established breweries located downtown by 1860.

In addition to Schwitzgebel's Kansas City Brewery, two other breweries were listed in the city directory for that year. John Lenhard is noted as a brewer at Fifth and Cherry in the city directory but is absent the following year. No other information is available about how long it operated. Meanwhile, G.S. Raffaletti is listed in the directory with a designation of "wines and liquors, Main and Walnut." Raffaletti's second listing is tied to Pacific Brewery.

1860: PACIFIC BREWERY, WESTERN BREWERY

German immigrant Heinrich W. Helmreich moved from St. Louis to Kansas City in the late 1850s and partnered with Gaudenzion S. Raffaletti to enter the brewing business in a building located on East Commercial, a street just south of Levee. The *Missouri State Gazetteer and Business Directory* of 1860 also lists a Kansas City Brewery under Raffaletti and Helmreich. Helmreich left Raffaletti sometime in 1860 for unknown reasons.

Records from *Missouri's Union Provost Marshal Papers: 1861–1866* show that on August 7, 1862, Raffaletti secured an "oath, bond and permit for the introduction and sale of liquors within the limits of the Central Division of Missouri." It appears that he entered the saloon business and operated it between Main and Walnut.

Meanwhile, Helmreich formed a separate partnership in 1860 with George Messerschmitt to found Pacific Brewery on East Levee near Cherry. They moved the brewery in 1862 to a location at Twenty-third Street and Westport Road, a half mile south of the city limits at the time. Messerschmitt passed away in 1865.

In 1870, Helmreich began using the name Western Brewery with Henry Helmreich and Co. listed as proprietor. Helmreich's partners were son-in-law Martin Keck and Charles Raber. Raber was a retired western freighter, brewery worker and billiard hall keeper. Raber, not achieving much success in the brewing industry, sold out of the business after two years.

As of 1870, the *Daily Journal of Commerce* reports that the capital invested was about $30,000. Western Brewery employed six men and three wagons, and daily production amounted to about forty barrels.

Meanwhile, the 1870 city business directory reported that by the end of August 1869, Western Brewery had manufactured three thousand barrels of beer for the year, valued at $39,000, and employed seven hands. The directory stated that the proprietor, "Mr. Helmrich [*sic*], being a gentleman of enterprise and energy, having stood by the city and grown with its growth, to-day ranks as one of the best and most respectable breweries in our midst."

The brewery changed hands several times. It was sold in 1871 to Hermann Wolfkule, a saloon owner, and August Kuge. In 1872, Henry Glyckherr bought the brewery. The brewery was no longer in operation by the following year.

1863: Muehlschuster and Sons Brewery, Grand Avenue Brewery

Michael Muehlschuster operated a brewery at Twentieth Street and Grand Avenue after the Civil War. The brewery name changed in 1867 to Muehlschuster and Sons and operated until 1868. Sons Anthony and Joseph are listed under the same address in the city directory. Frank Muehlschuster, whose exact relationship is unknown, worked as a bartender at Garden City House in 1865. He began working at the brewery within the next two years.

Prior to 1869, Frederick Hey established Grand Avenue Brewery, located at the corner of Grand Avenue and Twentieth Street, likely succeeding Muehlschuster and Sons.

The 1870 city business directory indicates that by August 31, 1869, Grand Avenue Brewery had manufactured four thousand barrels of beer, valued at $52,000; employed a half dozen workers; and had $35,000 in capital invested. The *Daily Journal of Commerce*, dated February 26, 1870, reported that the brewery had a capital investment of $20,000, produced twenty barrels per day and employed five men and two wagons.

As these two reports were published a few months apart suggest, exact business figures varied depending on the source.

The city directory no longer lists Grand Avenue Brewery after 1870. Frederick Hey's personal directory listing shows that he began work in the flour and feed business.

1864: Post Civil War

As the Civil War subsided, Kansas City competed with Leavenworth, Kansas, and St. Joseph, Missouri, for a railroad line that would help a city assert trade dominance in the area. In 1865, the Missouri Pacific arrived as Kansas City's first railroad, effectively ushering out the steamboat era. The construction and opening in 1869 of the Hannibal Bridge across the Missouri River at Broadway Avenue was a major boon to Kansas City's economy. As wheat and cattle were shipped from prairies to the city, Kansas City's stockyards and livestock exchange became one of the world's largest cattle markets.

Railroad lines provided essential arteries that enabled beer distribution from eastern breweries to saloons in the Midwest. Meanwhile, more local

breweries sprang up and closed during this heady time. Rural workers relocated to fast-developing cities like Kansas City. With higher-paying jobs, workers had more disposable income to spend. Saloons and taverns thrived in proximity to brewery depots and train stations built near railroad lines and an urban workforce.

1866: MAIN STREET BREWERY

George Hierb began operating a brewery around 1866 at 1734–40 Main, near where Gallup Map Co. is now located. A natural artesian well existed by the property. By 1869, Hierb brewed three thousand barrels of beer per year, generated $40,000 in annual sales and employed six people.

The 1870 city business directory published this complimentary report: "This brewery is in operation three years, and is conducted by a gentleman who is a first-class brewer, and who understands his business thoroughly. He has a large shipping trade, while his beer in the city has an extensive and increasing sale. Mr. Hierb is an enterprising gentleman and justly deserves the extensive patronage which he receives."

Hierb sold the brewery in 1870 to George and John Muehlebach.

1867-72: KANSAS CITY'S POPULATION SURGES

Kansas City's population jumped from more than fifteen thousand in 1867 to twenty-five thousand in 1868 and more than forty thousand in 1872. The city was booming. By September 1869, eight railroads from St. Louis, Louisiana, St. Joseph and other destinations passed through the city. Goods, people and natural resources flowed inbound and outbound. A thirst for alcohol came with that growth.

Operating breweries at this time included Peter Schwitzgebel's Third Street Brewery (aka Kansas City Brewery); Main Street Brewery operated by Muehlebach & Bro.; F.H. Kumpf & Co.'s brewery (formerly Star Ale Brewery); Western Brewery, now owned by Wolfkule and Kuge; and a short-lived brewery listed only under Benjamin Mason at 1515 Hackberry that lasted two years. No other mention of Mason's brewery exists in city records in subsequent years. George Hierb's sale of Main Street Brewery to the Muehlebach brothers led to the city's most enduring brewery of its era.

1868: George Muehlebach Brewing Company

Swiss-born George Muehlebach and his three brothers came to the United States in 1859, moved west and settled in Kansas City. George and brother John bought Main Street Brewery (1734–40 Main), located near an extremely cold freshwater well at Eighteenth and Central Streets. The Muehlebachs installed a four-inch pipe from the well to the brewery, providing an ideal water source for brewing beer. The brothers experimented with various beer recipes brought by the family from Switzerland. The grain bill included barley, corn and rice in the brewing process. The business would gradually emerge as a leading major brewery in its era.

By 1875, the brothers had made significant upgrades and built modern cellars on the brewery premises. Toward the end of the decade, the brewery produced nearly four thousand barrels and became the city's second-largest brewery after F.H. Kumpf's Star Ale Brewery. After John died, George rebuilt and expanded the brewery in 1880 using brick and stone. The sturdy building became known as the Beer Castle. Brewmaster Leo Wolf oversaw brewing operations.

Muehlebach's Pilsener brand proved so popular that it was only distributed locally for consumption. According to advertisements for Pilsener, the beer was many things, including "a cool, refreshing, invigorating and genuine thirst-quenching beverage, especially brewed from the choicest hops and best malt available." Further, Pilsener was "delicious, pure and wholesome." Finally, the beer was "a boon to the Invalid and Convalescent; also best for table and family use." Apparently, Pilsener was a miracle beverage for anyone who consumed it.

The brewhouse, stock house and engine house expanded several times from 1897 to 1907 to increase capacity from 15,000 barrels to more than 50,000 barrels. In 1908, the brewery constructed a new stock house and bottling building. By 1910, the brewery's capacity reached 80,000 barrels per year. Muehlebach Brewery was Kansas City's second-largest brewery at the time and trailed Kansas City Breweries Company, a company formed in 1905 when Heim, Rochester and Imperial breweries consolidated. Once Muehlebach added two floors to its stock house for storage, its capacity reached 100,000 barrels.

Muehlebach beer was delivered by beer wagons to an average of twenty-eight thousand homes annually from 1909 to 1919, according to a 1972 account in the *Kansas City Times*.

The Muehlebach brewery's name changed many times during its existence. Known as the Main Street Brewery from 1870 to 1884, it became Muehlebach Brewing Company—Main Street Brewery until 1890. The identity evolved to the George Muehlebach Brewing Company from 1903 until Prohibition. During Prohibition, the word "brewing" was dropped from the company name.

George E. Muehlebach, son of George Sr., served as president of the brewery from 1905 through Prohibition. He was also president of the Muehlebach Estate Company and oversaw the family's vast real estate holdings. The company built the Hotel Muehlebach in 1916 at Twelfth and Baltimore, which is now part of the Marriott Hotel.

George E. also purchased the American Association baseball field at Twenty-second and Brooklyn near historic Eighteenth and Vine. The new owner built a stadium in 1923 for $400,000 at the park, known as Muehlebach Field, where the Kansas City Blues and Negro League Kansas City Monarchs played. The stadium was renamed twice when it changed ownership and ultimately became Municipal Stadium, home of the Kansas City Athletics.

Political and public support coalesced for the repeal of Prohibition, which ended in December 1933. Carl Muehlebach, acting president of the Muehlebach Estate Company and George E.'s brother, explored options to reopen the brewery. Initial efforts at raising financing through a stock offering proved futile. By the spring of 1937, a private stock offering among a dozen stockholders secured the needed capital.

When it reopened in 1938, the business was known as the Geo. Muehlebach Brewing Co. and changed location. The new brewery opened at Fourth and Oak Streets, former home of a cold storage facility owned by the Western Ice Service Co. The complex spanned several blocks and multiple buildings, including a one-story bottling warehouse (303 Grand), a storage building (318 Oak Street), a keg washing building (315 East Third Street) and cold storage (414 East Fourth Street). Two spurs of the Kansas City Southern Railroad linked the brewery directly to a main rail line and connected Kansas City with markets in Texas and Louisiana, fostering widespread distribution.

The original formulas for Muehlebach Pilsener and Lager were brought back into production. Muehlebach Pilsener in the famous green bottle was sold exclusively at the bar of the Muehlebach Hotel until 1920. Other brands produced by the brewery included Muehlebach Special, seasonal Bock beer, Kroysen (introduced in 1951) and Malt Liquor by Muehlebach (introduced around 1952). Each beer brewed underwent a total of forty-

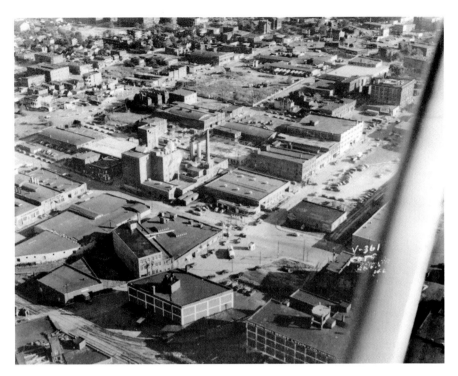

An aerial view of the Muehlebach Brewery at Fourth and Oak Streets, circa 1940. *Courtesy of Missouri Valley Special Collections.*

four laboratory tests for quality and uniformity of taste and appearance, according to company marketing brochures.

Shortly after the 1938 relaunch, George Muehlebach Brewing Company bought Champion Brewing Company in 1940 on Lone Star Boulevard (formerly Simpson Street) in San Antonio, Texas, and renamed the business Lone Star Brewing Company. It began brewing Lone Star Beer that year. The beer was known as "the national beer of Texas." Nine years later, Muehlebach divested itself of ownership.

Muehlebach's annual brewing capacity expanded to 175,000 barrels by the time the United States entered World War II. The global war sapped resources in grain, manpower and equipment, but the brewery continued to grow in sales and capacity. Postwar, capacity surged to 325,000 barrels, with sales in 1947 reaching 244,00 barrels. Three bottling lines and one canning line ran steadily to keep up with demand.

Muehlebach's distribution expanded and contracted in surrounding states. At different points in its history, the brewery's territory included

Missouri, Kansas, Oklahoma, Texas, California, Iowa, Illinois, Louisiana, Arizona, Arkansas, Colorado, Minnesota and Nebraska. By 1955, the beer was available in ten states.

Muehlebach expanded a fourth time since 1938 by commissioning the building of a stock house to age beer and another building to store finished product. A fourth bottling line was also added. By the end of 1950, Muehlebach's capacity reached 375,000 barrels, with annual production of 200,000 barrels. Construction and $1 million in investment ensued to further expand the brewery. Despite this growth, competition from other major regional breweries in the Midwest, namely Milwaukee-based Joseph Schlitz Brewing Company, took a share of Muehlebach's Kansas City market.

During the 1940s, San Miguel Corporation, owner of San Miguel Brewery, Inc., held a partial initial stake in George Muehlebach Brewing Company and majority holdings in the Lone Star Brewing Company. San Miguel Brewery is the largest producer of beer in the Philippines and Southeast Asia. San Miguel Beer became another beer brand brewed and packaged in part by Muehlebach.

A brick building at Oak Street and Independence Avenue is the Muehlebach brewery's last remaining structure. The brewery's name is inscribed in stone near the roof. *Photograph by Pete Dulin.*

Led by San Miguel Corporation chairman Andres Soriano, the company eventually acquired a majority stake in Muehlebach. Soriano took Carl Muehlebach's place in 1947 as the brewery's chairman of the board. Muehlebach posted a net loss of $272,281 for the fiscal year ending November 30, 1955. The brewery lost money in the year prior as well. In 1956, San Miguel sold the brewery, then touting an annual capacity of 500,000 barrels, and its buildings to Schlitz. The estimated $2.5 million sale represented the first acquisition by Schlitz of an inland brewery property.

The only remaining physical remnant of the Muehlebach brewery is a two-story brick building at the corner of Oak Street and Independence Avenue. The original four-story Muehlebach brewery at Eighteenth and Oak was demolished in 1941 after machinery was removed. Trans World Airlines established its corporate headquarters on the site, and construction was completed on October 31, 1956. The building's exterior was decorated in TWA's signature red and white corporate colors. The airline moved its headquarters to New York in 1964. Today, the building serves as the headquarters of advertising agency Barkley, Inc.

Muehlebach Brewing Co. played a major role in the development of regional beer culture, product branding and consumption. Further, it was the first Kansas City brewery to extend its local brand to multiple states outside the Midwest. Despite its growth, Muehlebach failed to transition into a national brand, unlike other regional breweries with large manufacturing operations and economies of scale in production, distribution and sales. Nonetheless, the Muehlebachs built a company that maintained a mighty presence for nearly ninety years.

1869: Star Ale Brewery, F.H. Kump Brewery

Frank Hubbard Kumpf moved with his parents from Chicago, Illinois, to Kansas City, Missouri, in November 1859. With dark parted hair trimmed short, robust mustache and fine features, he appeared to be a distinguished gentleman. He established a soda and mineral water bottling business on Walnut Street near Fourteenth Street with business partner Joseph Haag. When the soda business slowed in winter months, the company manufactured brooms. They built a sizeable company as a producer and bottler of soda and mineral water, root beer, ale and porter made by others. The beer was sold in barrels, half barrels and bottles.

Competition from other soda water bottlers intensified. In 1867, the firm moved to Fourteenth and Main, where the partners purchased and prepared a building for brewing ale to diversify their business. Kumpf sought and received investment from his brother in the East to complete Star Ale Brewery. Within two years of opening, Kumpf bought out his brother's share of the brewery. Haag subsequently withdrew from the business in 1869 over a dispute in profit-sharing.

The 1870 city business directory showed that by August 31, 1869, Star Ale Brewery had manufactured four thousand barrels of ale and porter, amounting to $48,000, as well as sixty thousand dozen packages of soda water, valued at $20,000, and employed fifteen workers.

Byron Dye, who later became superintendent of the Horse Railroad Company of Kansas City, bought a half interest in the brewery. He remained a partner until the spring of 1873. Kumpf changed the brewery's name to F.H. Kump Brewery (dropping the "f" from the name) that year. By 1879, the brewery had a three-story complex composed of six buildings, including three icehouses, and produced 8,700 barrels per year. Beer was delivered by horse-drawn wagon to saloons several times a day. Kumpf continued as sole proprietor until he retired in 1884 due to ill health. The brewery was then sold in 1884 to Ferdinand Heim Sr., founder of Heim Brewing Company.

Chapter 2

Out-of-Town Competition Brews

LATE 1800s: PASTEURIZATION, TECHNOLOGY AND TRANSPORTATION

Louis Pasteur's discovery and development of pasteurization proved invaluable for the beer and wine industry and, much later, for the milk industry. In the mid-1860s, Pasteur discovered that wine and beer could be slightly heated to kill bacteria that caused spoilage. Pathogenic microbes were killed without marring the quality of the beverage and, in fact, prolonged its quality over time. Pasteur published *Études sur la Bière* ("Studies on Beer") in 1876 to share the results of his research and experiments. His publication included plans for a fermentation tank that would prevent airborne bacteria from entering and spoiling the brew.

Enterprising Adolphus Busch adopted this method first in 1872. Steaming or "pasteurizing" beer enabled the Anheuser-Busch brewery in St. Louis to brew and ship beer long distances without spoilage. Pasteurization became standard practice for beverages and food and remains so today.

Nationally, beer became a mass-produced and mass-consumed beverage. Advances in railroad transportation, bottling, refrigeration and production and storage of ice all aided growth of the brewing industry. Locally, Muehlebach grew and expanded into other markets because of these advances. Meanwhile, out-of-town breweries with the same advantages competed for market share in Kansas City.

1873: DICK BROTHERS BREWERY, DICK & BROTHERS QUINCY BREWERY COMPANY

Kansas City served as a base for many depots and branches established by out-of-town breweries such as Dick Brothers Brewery, based in Quincy, Illinois. Previously, beer was shipped by cask and keg but risked spoilage. The use of pasteurization, stronger glass bottles, refrigerated boxcars filled with ice blocks and expanded railroad lines made bottling and shipping beer to other markets a viable option for breweries with sufficient capacity.

Depots and branches of breweries were set up near railroad lines in other cities. These outlets stored beer and distributed it by wagon to saloons and taverns. Completion of the railroad bridge across the Missouri River in Kansas City enabled breweries from Milwaukee, Chicago, St. Louis and other points to expand their reach. Agents worked with towns along rail lines to take and fulfill beer orders. If demand generated enough large-volume orders, the brewery built a branch that included a bottling operation.

Dick Brothers Brewery was the first out-of-town brewery to establish a presence in Kansas City. Its western depot, located at 1300 West Tenth Street (Tenth and Mulberry) in the West Bottoms, supplied several midwestern states, including Missouri and Kansas. Dick Brothers' Kansas City branch competed directly with local breweries. The brewery maintained strong market share in Kansas City and throughout the Midwest until Prohibition.

1877: ANHEUSER-BUSCH BREWING COMPANY

St. Louis–based Anheuser-Busch, founded in 1860 as E. Anheuser & Co., originally established a branch in 1869 in Lawrence, Kansas, and moved it in 1877 to 414 Main Street in Kansas City. This branch did not brew beer but did bottle beer made elsewhere. The brewery opened a branch in 1883 at Twentieth and Walnut and expanded the operation three years later. The branch included a two-story office in a brick building, bottling department, stables and stalls for horses and wagons that delivered beer around town. The Kansas City branch once employed nearly two hundred workers.

After Prohibition, breweries were no longer legally allowed to distribute their own alcoholic beverages. Breweries worked through wholesale distributors in specific territories in local markets. Boss Tom Pendergast secured the prized Kansas City A-B distributorship for his son, Tom Jr. Phil McCrory,

a member of Pendergast's inner circle and a trusted business associate, actually ran the distributorship known as City Beverage. Tom Jr. oversaw operations of City Beverage until 1955, when he sold the distributorship back to Anheuser-Busch. Anheuser-Busch, now a multinational corporation known as Anheuser-Busch InBev, currently distributes its products in Kansas City through United Beverage LP. St. Louis remains the primary base in Missouri for the brewery's U.S. operations.

1879: PABST BREWING COMPANY

The Philip Best Brewing Company, later known as Pabst, established a Kansas City branch at 100 Main in 1879. The brand gradually expanded its facilities to a much larger footprint over the next twenty years. The Milwaukee-based brewery was the largest in the United States by the early 1880s and in 1893 produced one million barrels of beer.

In 1900, the brewery built a new office building and bottling works in Kansas City that it soon outgrew. Eleven years later, the depot moved to a two-story building at Twenty-first and Central Streets. Pabst owned several Kansas City saloons as an extension of its branch to maximize sales with exclusive pouring rights. Post-Prohibition, the practice of brewery ownership of saloons and taverns ceased.

During Prohibition, Pabst brewed a near-bear, cereal malt beverage with 1 percent alcohol and a brand called Kulmbacher distributed in Kansas City by T.J. Pendergast Liquor Distributing Co. By 1920, Boss Tom Pendergast controlled the Pabst depot operation at Twenty-first and Central. He used it as a warehouse for his own distribution purposes but did not sell bootleg alcohol to avoid running afoul of federal agents. Pendergast may have used the building to store an estimated fourteen thousand barrels of beer and 1,500 cases of liquor in stock during Prohibition.

1880: VALENTIN BLATZ BREWING COMPANY

This Milwaukee-based brewery opened its Kansas City branch in a two-story brick building. *Hometown Beer* gave the branch address as 216–18 East Levee, placing the building on the north side of the Missouri River and

east of the once thriving Harlem neighborhood. The 1890 city directory for Kansas City listed the Blatz business address at 116–88 East Front Street, with W.A. Stumpe as the agent. The 1918 *Brewers Directory* simply listed the brewery's Kansas City branch "at the foot of Walnut St."

One of these two latter locations is more likely, based on a 1881 photograph in the Kansas City Public Library's Missouri Valley Special Collections. The image shows the Blatz brewery in the foreground near a dirt road, railroad tracks, rail cars and a small building likely used to offload shipments. The photograph caption indicates a view "looking north across the Missouri River towards Harlem during flood." That sightline places the Blatz building on the south side of the river.

Blatz successfully distributed barreled beer in Greater Milwaukee. National distribution was hampered because barreled beer didn't travel well in different climates. Blatz circumvented this by contracting with Milwaukee bottlers Torchiani & Kremer. The company bottled Blatz beer in a newly established bottling department and expanded the brewery's capacity and distribution. Blatz began a national marketing campaign, and Blatz beer was shipped to cities throughout the United States, including Kansas City, and Mexico.

Blatz incorporated his brewing operation in 1889 under the name Valentin Blatz Brewing Company. He sold his interests in 1891 to British and U.S. investors incorporated as the United States Brewing Company, known variously as the "English Syndicate" or the "Chicago Syndicate." The brewery's branch in Kansas City went through a succession of agents until Prohibition.

1880: JOSEPH SCHLITZ BREWING COMPANY

This Milwaukee brewery's Kansas City depot (959 State Line Road) was near "the Wettest Block in the World," a section of the West Bottoms filled with saloons. The depot building no longer exists at the end of the rough road.

The thirty-two-year-old brewery sold more than 200,000 barrels per year and shipped Schlitz beer across the United States, Mexico, Central America and Brazil. Brands included Pilsener, Schlitz's Porter, Extra Pale and Extra Stout. The KC depot operated until 1919, when Prohibition took effect. Once Prohibition was repealed, Schlitz returned to Kansas City in 1933 and sold its beer through a distributor instead of a depot.

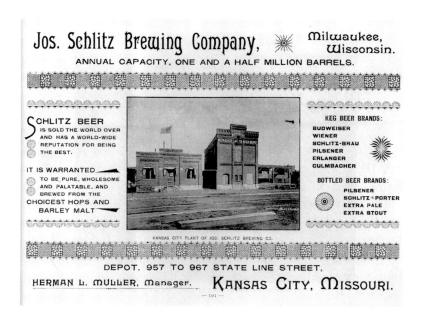

An advertisement for Schlitz Brewing Company and its depot at Ninth and State Line Roads. *Courtesy of the Jackson County Historical Society Archives.*

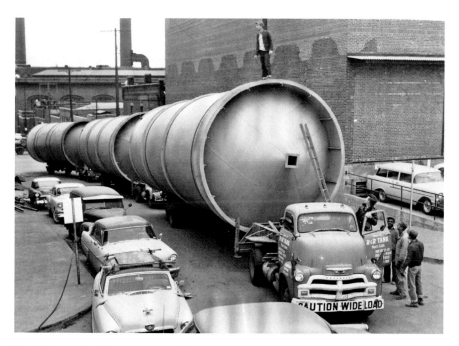

Four fifty-one-foot-long, ten-ton steel grain storage tanks were delivered to Muehlebach Brewing, later owned by Schlitz, near Fourth and Oak Streets, circa January 7, 1957. *Courtesy of the Mark Frazier collection.*

By the 1950s, national brands like Schlitz, Pabst and Anheuser-Busch rivaled local breweries such as Muehlebach Brewing Company. Schlitz aggressively expanded its market share in Kansas City, leading to Muehlebach's decline.

For example, when the Kansas City Athletics baseball team played home games at Municipal Stadium—formerly Muehlebach Stadium—Schlitz maneuvered to become the team's official "hometown" beer sponsor for the next two years. By 1956, Schlitz had acquired Muehlebach Brewing, which faced diminishing sales and market share under ownership of the San Miguel Corporation.

Schlitz ran the Muehlebach plant, which occupied a four-square-block area between Third and Fifth Streets and Grand and Oak Streets. The plant operated with an annual capacity of a half million barrels and served Schlitz wholesale distributors throughout the Midwest and outlying states such as Colorado and Texas. Schlitz decided to upgrade its operations in 1971 with a new $250 million plant. The company built a new brewery in Memphis rather than upgrade its Kansas City plant. Schlitz closed its Kansas City brewery in September 1973.

1880s TO EARLY 1900s:
OTHER DEPOTS AND BRANCHES

During the late 1800s, many out-of-town breweries operated depots and branches in Kansas City, such as Green Tree Brewery and Wm. J. Lemp Brewing Company from St. Louis. Chicago-based Ernest J. Tosetti Brewing Company, Peter Schoenhofen Brewing Company and Keeley Brewing Company operated depots in Kansas City. Michael Keeley of Keeley Brewing Company in Chicago opened a Kansas City branch at 1924 Grand Avenue in 1903. It changed locations in 1911 and moved to 1908–10 Walnut. The brewery, which made lager, ale and porter, distributed in Kansas City until Prohibition.

Fred Miller Brewing Company from Milwaukee, Wisconsin, opened a Kansas City office at 1908 Grand in 1904. Seven years later, the brewery opened a depot at 506 Grand. Gottlieb Heileman's brewery, based in La Crosse, Wisconsin, expanded to Kansas City in 1912 under the name of Heileman Brewing Co. The George Wiedemann Brewing Company, based in Newport, Kentucky, began operating in Kansas City in 1905 at 1812

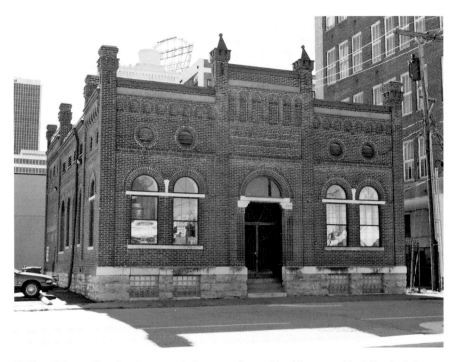

William J. Lemp Brewing Company's depot was located in this restored building built in 1895 at 215 East Twentieth Street. *Photograph by Pete Dulin.*

Main Street. The brewery moved to two addresses on the 300 block of Delaware several years later.

M.K. Goetz Brewing Company, established in 1859 in St. Joseph, Missouri, constructed a brewery in Kansas City after Prohibition. The brewery opened on May 25, 1936, on the old Ringling Brothers–Barnum & Bailey Circus grounds on the northeast corner of Seventeenth and Indiana. It had an annual capacity of 100,000 barrels and produced popular brands such as Country Club Malt Liquor in cans. Prior to then, the Goetz brewery operated a depot in two locations on Grand Avenue between 1906 and 1908. By 1913, the brewery established a new office at Seventh and Mulberry Streets. By 1947, the St. Joseph and Kansas City breweries had a combined annual capacity of 650,000 barrels. Goetz eventually closed its Kansas City operation and concentrated efforts in St. Joseph. By 1960, Goetz Brewing had merged with Pearl Brewing of San Antonio, Texas. The 83,970-square-foot Kansas City brewery property was sold to investor Jack Genova and converted into warehouse space. Sears acquired the site; leveled the structure, including a smokestack prominently displaying the Goetz name; and built a bigger warehouse.

Additional out-of-town breweries with a Kansas City footprint during the early 1900s included Milwaukee-Waukesha Brewing Company of Milwaukee, Wisconsin; Hamm Brewing Company of St. Paul, Minnesota; Schuster Brewing Company of Rochester, Minnesota; John Hauck Brewing Company of Cincinnati, Ohio; and Minneapolis Brewing Company. Five St. Louis–based breweries formed the Independent Brewing Company in 1906 and attempted to break into the Kansas City market ten years later, only for the venture to last one year. Union Brewing opened an office at 1519 Main in 1917 and closed a year later.

Prohibition largely wiped the slate clean of local and out-of-state breweries. Surviving operations switched to producing and bottling soda water, near-beer and other products. Without the disruption of Prohibition, Kansas City's biggest brewery operations at the time, Muehlebach Brewery and Heim Brewery, would have faced stiff ongoing competition from large Midwest breweries.

Chapter 3

Temperance and Temptation Along the Kansas-Missouri State Line

CIRCA 1880: THE WETTEST BLOCK IN THE WORLD

A block in the West Bottoms of Kansas City near a railroad line and Union Depot became known as the "Wettest Block in the World." James Flanagan's place at 1724 West Ninth Street was one of many popular saloons that occupied the strip between State Line Road and Genessee. Of the two dozen buildings packed along that block at the time, twenty-two of them operated as saloons or liquor stores.

Horse-drawn carts carried passengers past men in suspenders, jackets and hats standing along the block. Businesses included Mike & Frank's at 1700 West Ninth Street, where the side of the building displayed an advertisement for Sunny Brook Pure Food Whiskey and signage advertised Heim's beer on tap. Advertisements for Rochester Beer and Schlitz Beer adorned buildings. An elevated rail line ran down the center of Ninth Street, with a nearby station at the State Line intersection.

This stretch became popular not only because of the density of drinking establishments and prostitutes but also because it was within stumbling distance of the Missouri-Kansas state line. Missouri's political and social climate was (and remains) far more tolerant than Kansas, where the temperance movement and state prohibition laws curtailed the sale and consumption of alcohol. Kansan workers and residents near the state line knew that Kansas City's taverns and saloons flowed with booze. After a work shift, they stepped across the line and consumed beer and spirits in Missouri.

Now, Flanagan's is locked and full of dust and stored relics. Abandoned cars and weeds fill the fenced-in lot next to the building. Other buildings on the block are shuttered or used for storage and manufacturing. The nearest modern tavern is The Ship (1217 Union Avenue), a 1930s-era nightclub restored and relocated in the West Bottoms.

PROHIBITION AND TEMPERANCE IN KANSAS

The temperance movement in Kansas to limit or prohibit the use of intoxicating beverages dated back to the 1830s and gained momentum after the Civil War. In the late 1870s, the constitution in Kansas was amended to prohibit "the manufacture and sale of intoxicating liquors" in the state. The amendment was ratified by voters and took effect on January 1, 1881. The Kansas legislature passed a law months later that made manufacturing alcohol a misdemeanor.

The goal of radical hatchet-wielding Carrie A. Nation and other prohibitionists was total elimination of alcohol from Kansas. "Bone-dry" laws were passed in February 1917 "prohibiting the importation or manufacture or possession of intoxicating liquors for any purpose except in use in churches." Alcohol could only be sold for medicinal and scientific purposes under rigid restrictions. Additional acts gave cities power to enact local laws prohibiting the possession of intoxicating liquors.

National Prohibition followed when the Eighteenth Amendment to the U.S. Constitution was ratified on January 16, 1919. The law took effect from January 17, 1920, until December 5, 1933, when the Twenty-first Amendment repealed the Eighteenth.

Prohibition forced breweries, wineries and distilleries nationwide to close or manufacture other products. Under the reign of "Boss" Tom Pendergast, illegal booze from bootleggers still flowed in Kansas City, the Paris of the Plains. When Prohibition was repealed, a brewery opened in Kansas City that same year. Kansas would not see another brewery operate until Free State Brewing Company founder Chuck Magerl spearheaded efforts with the state legislature to change its laws and allow local brewing once again. More than a century had passed since the state's prohibition law was enacted in 1881. Magerl's brewery opened in 1989 and led the vanguard for modern brewing in Kansas.

Chapter 4

1880s to Prohibition

1884: Ferdinand Heim Brewing Company, Bavarian Brewing Company and Kansas City Breweries Company

Ferdinand Heim Sr. of St. Louis–based Heim Brewery came to Kansas City with his three sons, Ferd Jr., Michael and Joseph, and brewery foreman Phillip Koppf on a mission. The group inspected the Star Ale Brewery, owned by F.H. Kumpf & Company and located at Fourteenth and Main Streets. Heim purchased the operation, the largest brewery in Kansas City at the time, with an annual production of twelve thousand barrels. The company continued operations as the newly formed Ferd. Heim Brewing Company.

In 1887, Heim purchased a sugar refinery and acreage in the East Bottoms and built a new brewery on the northeast corner of Guinotte Street at Agnes. The fourteen-acre site included a malt house, elevator and large ice and refrigeration plants. This site later became the setting for Electric Park, an amusement park and beer garden.

The brewery shipped beer on company-owned refrigerator cars, using railroad tracks on company property, to towns and cities through the Midwest. Stock house No. 2 housed a vat with a capacity of ten thousand kegs, the largest storage vessel for beer in the world at the time.

The former Kumpf plant at Fourteenth and Main was eventually sold and renamed Bavarian Brewing Company about 1890. Michael G. Heim led the brewery as president. It closed in 1894, after yearly sales dropped to eighteen

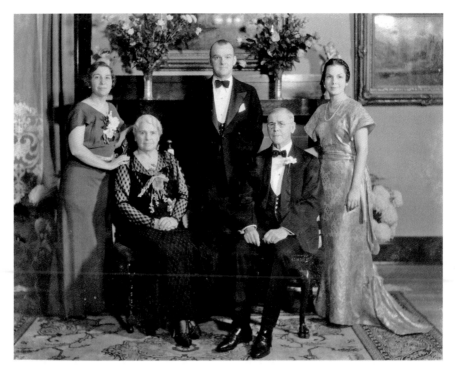

Ferdinand Heim Jr. (seated right) and Mrs. Ferdinand Heim Jr. (standing far left), circa 1934. *Courtesy of the Jackson County Historical Society Archives.*

thousand barrels. Production of Bavarian's Kyffhauser and Baierisch brands were shifted to the new Heim brewery in the East Bottoms. Heim Brewing produced a number of brands, including Heim's Scharnagel Select aimed at a female audience, Hedderman's Cream beer, stronger bohemian Kyffhauser and the upscale Heim's Wisconsin Club. By 1890, sales jumped to nearly sixty thousand barrels. A Hop Tea Tonic was produced as a non-intoxicating beverage for distribution in Kansas, where the state's 1881 prohibition law curtailed beer sales.

In 1889, Ferd Heim Sr. sold the original Heim Brewery Company in East St. Louis, originally launched in 1870, to the St. Louis Brewing Association. The family concentrated its resources in Kansas City. Brewmaster Koppf, who had moved from East St. Louis to Kansas City, oversaw production at Heim's Kansas City operation until his death in 1899.

Ferd Sr. passed away in October 1895. Eldest son Joseph managed the company as president and Ferd Jr. was corporate secretary, while Michael acted as plant superintendent of the Heim Brewing Co.

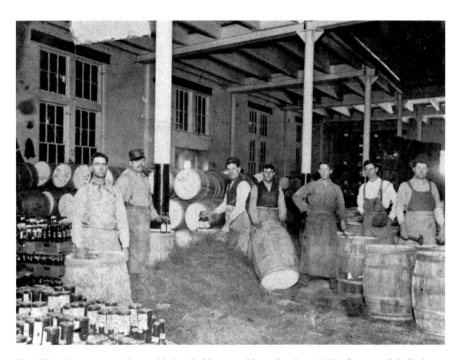

Ferd Heim brewery workers with bottled beer and barrels, circa 1900. *Courtesy of the Jackson County Historical Society Archives.*

Heim depots were established in Des Moines and other cities. The East Bottoms brewery grew when two additional brick buildings were added along with a new engine house and five-story stock house. The Heims also built Heim No. 20, a firehouse, on the property as a safety measure. The brewery experienced two fires in 1896 and another in 1899 in the bottling works. By 1898, the brewery had installed three-hundred-ton and four-hundred-ton refrigeration machines. A one-hundred-ton ice plant was also located on site. By 1899, Heim Brewing's annual production surpassed 120,000 barrels.

Michael Heim spearheaded the idea for Electric Park, an amusement park known for its light displays after dark. Construction began in 1896, and the project was completed three years later. Electric Park operated until 1906. At the time, electric lights were still a novel luxury and part of the amusement park's allure. Admission was ten cents.

The park resembled the Vatican Gardens that Joseph Heim had once visited on a trip to Italy. This entertainment complex offered picnic tables, band concerts, bathing facilities, boating, roller coaster rides and a vaudeville and opera theater that seated 2,800. Naturally, Heim's beer was served to

the public in a German-style beer garden piped directly from the brewery. In 1907, Electric Park was dismantled and moved to the corner of Forty-seventh and Paseo. This version of the park, illuminated with more than 100,000 electric light bulbs, burned to the ground in 1925.

An 1897 article in *Electrical Review* reports that the East Side Electric Railway Company filed articles of incorporation with the State of Missouri. The stockholders were Joseph Heim, Ferd Heim, Michael Heim and C.S Palmer. Managed by the Heim brothers, the railway operated along an electric line on East Fifth Street from Walnut Street (in today's River Market) to Lydia Avenue. The line continued north to Guinotte Avenue and east to Otis Avenue, which was within a block of Heim's brewery, and north again to Nicholson Avenue.

The Heim brothers also commissioned the building of a road, North Montgall Avenue, that connected Guinotte at the south end and Nicholson Avenue to the north. Today, the butcher shop Local Pig sits at the corner of Guinotte and North Montgall. Originally, a powerhouse for a double-track railway was located at the opposite end of the road at Nicholson and North Montgall. This station and generators at the brewery powered the railway. Allegedly, the Fifth Street line was intended to transport workers from nearby downtown homes to the plant, but workers didn't want to pay the toll. The streetcar line proved more successful and profitable as a means to transport adventure-seekers to Electric Park.

Proprietor Ed J. Smith ran a pre-Prohibition saloon in this East Bottoms building. In 2012, Local Pig butcher shop opened in the building at North Montgall and Guinotte Avenue on the former Heim Brewery property. *Photograph by Pete Dulin.*

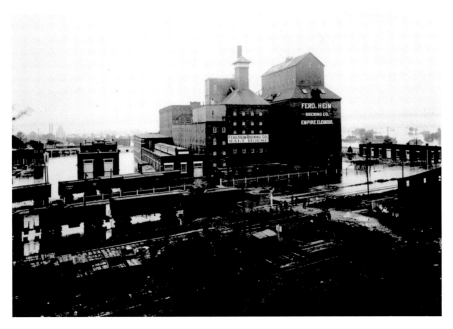

Ferd Heim brewery in the East Bottoms surrounded by floodwaters, circa 1903. *Courtesy of Missouri Valley Special Collections.*

In 1900, Heim Brewing constructed a modern two-story bottling building, designed by architect Charles A. Smith, at 507 North Montgall that still stands. A pipeline connected the bottling building to the brewery. By then, the brewery was the largest in Kansas City. A fire in 1901 completely ruined an icehouse, but the brewery continued operations, employed 250 people and expanded capacity to 150,000 barrels per year.

More disaster struck in the following years. The Heim brewery and much of Kansas City suffered great damage when the Kansas River breached its banks on May 30, 1903, and flooded the river bottoms. The aftermath of the flood resulted in nineteen deaths. More than twenty-three thousand people lost their homes, sixteen of seventeen bridges were destroyed, more than two hundred taverns were flooded and total damages ran approximately $22 million.

Additional changes ensued as a merger swept through Kansas City's brewery industry. A group of Cleveland investors formed Kansas City Breweries Company (1010 Commerce building) in 1905, consolidating Heim Brewing, Rochester Brewing Company (also known as the J.D. Iler Brewing Company) and Imperial Brewing Company. The combined capacity of the

breweries rivaled Muehlebach Brewing. However, operational troubles were in store for Kansas City Breweries Company, riddled with debt after the Imperial Brewing acquisition and about to face Prohibition.

World War I (1914–18) and a sociopolitical war on alcohol took a toll on breweries. U.S. Congress passed the temporary Wartime Prohibition Act in November 1918, banning the sale of alcoholic beverages with alcohol content greater than 2.75 percent. The act was an attempt to preserve grain for use as food. Next, Prohibition spurred the demise of Heim Brewing's operations in Kansas City and St. Louis. Each operation was eventually sold to separate ice companies.

Few buildings remain from Heim's presence in Kansas City. The Bavarian brewery was torn down and replaced by a carriage factory shortly after 1894. The land at Fourteenth and Main was later used to erect a store and three apartment buildings. These buildings were razed to make room in 1921 for the vaudeville and movie house Main Street Theater. The theater changed ownership and names several times, becoming the RKO Missouri Theater in 1941, Empire Theater in 1960 and AMC Main Street Theater in 2009. Currently, Alamo Drafthouse Mainstreet, a movie theater chain known for its selection of craft beer, operates on or near the spot where beer was once brewed.

The Heim bottling department on Montgall in the East Bottoms was once home to former distributor and wholesaler Case Supply. The Heim No. 20 Fire Station, built in 1903, still sits at the corner of Guinotte and North Montgall. These touchstones to Heim are tied to a modern brewer.

John McDonald, who founded Kansas City–based Boulevard Brewing Company in 1989, purchased the Heim bottling building, the warehouse next to it and the fire station in the mid-2000s. The bottling building is used for storage. The fire station is now the headquarters of McDonald's venture, Bottoms Up Collective. McDonald quietly promotes renovation and development of East Bottoms properties. The intent is to attract and entice independent local businesses to open and thrive. The Local Pig, a butcher shop; Pigwich, a food truck; modern general store Urban Provisions; and J. Rieger and Co., a distillery owned and operated by Andy Rieger and Ryan Maybee, have established roots near Heim Brewery's historic grounds.

Meanwhile, architectural historian and consultant Cydney Millstein prepared and submitted an application in July 2015 to have the bottling plant listed in the National Register of Historic Places.

Former Ferd Heim bottling plant at 507 North Montgall. Building materials firm Case Supply once used the building as its headquarters. Boulevard Brewing Company now uses the space for storage. *Photograph by Pete Dulin.*

A faded advertisement for Ferd Heim beer on the wall of Bill Krzyzanowski Photography at 1800 Locust in the East Crossroads. *Photograph by Pete Dulin.*

1888: ILER AND BURGWEGER BREWERY, J.D. ILER BREWING COMPANY, ROCHESTER BREWING COMPANY

The Iler and Burgweger Brewery, located at Twentieth and Washington Streets, was founded by Omaha native Joseph D. Iler and Chicago native Leonard Burgweger, both men with ample brewery experience in their respective cities. Four years after its founding, the brewery's name changed to J.D. Iler Brewing Company when Iler became sole owner. The brewery, which expanded to Twenty-first Street, increased its annual capacity to 125,000 barrels.

In an unusual form of advertising, Rochester Brewing sponsored a beautiful set of twenty-two color lithographs that featured exotic scenes from around the world of the 1893 World's Columbian Exposition. The original watercolors were painted by Charles Graham, an illustrator for *Harper's*. The nine-by-twelve prints listed Rochester Brewery at the top and J.D. Iler, Kansas City, MO, at the bottom.

In 1895, the brewery's name changed to Rochester Brewery with Iler as president and Lawrence R. Rieger as manager and treasurer of the new corporation. When Iler retired in 1900, the company's name changed once again to Rochester Brewing Company but was referred to by its various names.

The *Kansas City Journal* reported on November 21, 1897, that J.D. Iler Brewing Company sent a shipment of its bottled Rochester beer to Yorkshire, England, upon request in time "for holiday entertainments." A group from Yorkshire had visited Kansas City several weeks earlier and "were hunting on their trip through the United States for a beer that met their approval." The group visited and inspected numerous U.S. breweries, sampled beers and found Iler's Rochester beer preferable among all others. The group noted that English beers were "too heavy for social drinking and there was a big demand there for a lighter brew of superior quality."

Previously, the English group had visited Canadian distilleries and asked for recommendations on suitable U.S. beer to ship home. A Canadian distiller was quoted as saying, "The best beer made in this country is made in Kansas City. Go and see Joe Iler and ask for the original Rochester brew."

Rochester Brewing merged with Heim Brewing to form Kansas City Breweries Company, which owned and controlled 150 saloons or "resorts" in Kansas City. The new company agreed to cease selling alcohol there in compliance with liquor laws, the *Washington Post* reported on July 10, 1906.

The Rochester brewery building and property was purchased by City Ice Company on July 26, 1919, after Prohibition forced its closing.

1890: George Grubel Bottling Works

This business (1100 North Second Street and State Avenue) primarily produced and bottled ginger ale, cider, mineral water and syrups. It also produced Berliner Weiss. A 1908 congressional report listed the brewery as having made improvements to the building and machinery amounting to $10,000 and stated that it was "now a modern plant, representing an investment of $35,000." The two-story brick building was destroyed by a fire, supposedly due to defective electrical wiring, on January 6, 1912. Losses amounted to $35,000. Grubel also had a two-story bottling works at the northwest corner of Front and Cedar Streets near railroad tracks that run parallel to the Kansas River in Bonner Springs, Kansas.

1896: Kansas City Bottling Company

Walter L. Schmidt operated a Berliner Weiss brewery at 1701 Holmes. The *Western Brewer Journal* recorded in 1913 that Helene Schmidt succeeded Schmidt. The brewery closed that year.

1898: P. Setzler & Sons

German-born Philip Setzler arrived in Kansas City in 1862. He partnered with A. Wolf in the liquor, cigar and wine business located on North Main Street. He soon sold out of that business and purchased four acres of land on Independence Avenue between Bales Avenue and Monroe Street. Setzler planted grapevines and began the manufacture of cider and wine. In 1884, he expanded to manufacture soda and mineral waters under the name of P. Setzler & Sons, proprietors of the Silver Rock Bottling Works plant at 3712 East Sixth Street.

Setzler's venture into brewing as Twin Springs Bottling Works was short-lived. According to *The Brewer's Handbook*, Setzler was listed as a new brewer of Weiss beer in 1898, and P. Setzler & Sons was listed under "Breweries Closed" by November 1899 in *The Brewers Journal*. The Setzler family shifted focus to its primary business of bottling soda water, ginger ale and, for a time, beer for other breweries.

1898: BREMER AND THOMA BREWERY, WEISS BEER BREWERY

German-born Leo Thoma learned the brewing trade by working for fourteen years at his older brother Otto's St. Louis–based brewery, Stettner & Thoma. Leo Thoma; his wife, Anna Bremer; and two children moved to Kansas City in 1898 to start Weiss Beer Brewery with his brother-in-law. The Bremer & Thoma brewery operated in the soda factory at Twenty-third Street and Westport Road once owned by H.W. Helmreich of Western Brewery. The partnership ended by 1900, and Thoma continued to operate Weiss Beer Brewery as sole proprietor. Thoma's son Leo E. also worked at the brewery. Bottles of beer were distributed with either the name Bremer and Thoma or Leo Thoma etched on the bottle.

The brewery relocated in 1910 to 1308 West Twenty-eighth Street and operated until Prohibition began. During Prohibition, the brewery became Leo Thoma Bottling Works with a focus on bottling carbonated beverages such as soda water. A family photo circa 1920 shows father and son working side by side on the bottling line. Leo Sr. sported a dark mustache and wore a dirty full-length apron to protect his clothing as he manned the line. He held a bottle brush. Stacks of wooden crates stamped "Leo Thoma Bottling Water Kansas City" were ready to be filled.

Post-Prohibition, the company briefly operated as a Schlitz beer distributor. It never reopened as a brewery. Today, the building is covered in vinyl siding and located near the Margarita's on Southwest Boulevard.

1901: IMPERIAL BREWING COMPANY, ROCHESTER BREWERY "B" PLANT

A massive late Victorian building constructed in the Romanesque Revival style from 1902 to 1905 once housed the iconic Imperial Brewing Company (2825 Southwest Boulevard). Originally built as a four-story building, the brewery still towers above restaurants and neighborhoods in Kansas City's Westside.

While clearly associated with Kansas City, Imperial Brewing Company's origins are connected to George E. Schraubstadter of St. Louis, former head of Galveston Brewing Company in Galveston, Texas. As principal, Schraubstadter enlisted investment from "well known saloon men who have trade relations with other brewers," as reported on November 15, 1899,

in the *Kansas City Journal*. Schraubstadter, associated with the American Brewing Company (ABC) of St. Louis for fifteen years, organized investors and saloonkeepers to invest in the venture. A.F. Stoeger, also affiliated with ABC, was vice-president of Imperial Brewing. The group secured an option for a four-acre tract. Plans involved construction of a $150,000 brewery with another $50,000 allotted for operating capital. One prospective site for the brewery was the West Bottoms. Land along Southwest Boulevard was ultimately chosen as the site.

According to a National Register of Historic Places registration form filed in 2010, A.F. Stoeger was the developer and Ludwig D. Briestag was the builder/contractor. The brewery site was chosen for its proximity to Southwest Boulevard, the railroad and a nearby dense population center. The site featured natural, fresh water from Turkey Creek, which has since been buried; a limestone bluff; and a quarry for building materials. Nearby railroad lines facilitated shipping and delivery of coal to the powerhouse. The power plant contained one of the most advanced boilers in the city of its era and generated steam for the facility at the time of construction. A two-story wing to the southwest of the brewhouse originally contained racking rooms, a washhouse and a shipping platform with direct access to the railroad. A horse stable, known as the mule barn, was built in 1902 with wagon storage behind the brewery. Barrels of beer were delivered by draft horse and mule via wagons to local taverns prior to the advent of bottling. An office and bottle works were built in 1903 on the other side of Turkey Creek.

Advertisements touted annual production capability at 100,000 barrels and $500,000 in construction costs for the expansive brewery. Brewing commenced in April 1902, and the first two beers, Mayflower and Imperial Seal lager beer, were released that May. Imperial Brewing's annual capacity was likely closer to 50,000 barrels.

Lager, a predominant beer style in the early twentieth century popularized by German immigrants, required cold temperatures for fermentation and cellaring. Imperial's new facility represented an emerging breed of large-volume breweries built to handle the more technical production, cold fermentation process and cellaring necessary for lagers. Imperial's Mayflower brand quickly attained a significant portion of local market share. Advances in refrigeration, electric power and pasteurization enhanced the ability to brew lager year-round and gave birth to the perceived appeal of "ice cold beer."

Cost overruns in construction and production overwhelmed the financial prospects of Schraubstadter and debt-ridden investors. In December 1905,

Imperial was purchased at auction for $99,500 by Kansas City Breweries Company, which also owned Heim Brewing and Rochester Brewing. Now referred to as Rochester Brewery "B" Plant, the former Imperial brewery began producing Kansas City Breweries' most popular lager, Old Fashioned Lager. Puritan was another brand introduced and touted as pure, wholesome and rich. In 1911, Imperial's annual volume reached an all-time high of 338,332 barrels.

Prohibition prompted Imperial's owners to shut its doors on December 16, 1918. Seaboard Flour Co. flour broker Otto Bresky acquired the property in 1919 and converted it to a flour mill and granary. Several companies owned the mill during its lifetime through the mid-1980s.

Located just behind Ponak's Mexican Kitchen, Imperial Brewing is still visible from I-35 Highway. Dean Realty Company currently owns the brewhouse and its stables, certified in 2011 as historic buildings. The future of the structure and property is ripe with possibility.

Chapter 5

Early to Mid-1900s

Short-Lived Breweries

Guttenberg Ale Brewing Company (2924 Fairmount), listed in the July 1900 issue of *American Brewers' Review*, brewed ale and porter under John G. Butler. Butler Ale Brewing Company took over operations in 1902 but closed in 1903, as reported in the October issue of *American Brewers' Review* that year.

The Swedish Ale Manufacturing Company (2928 Fairmount) opened in 1901 and closed in 1902, according to a listing in the October 1902 issue of *American Brewers' Review*. Around this time, city directories list Lion Brewing & Bottling (2940 Fairmount). These breweries ceased to be listed in directories by 1904.

In 1904, a Weiss Beer Brewery (20 East Twenty-fourth Street) appears in the city directory, but the listing is absent the following year.

Schiller Bros. Brewing (310 West Sixth Street) is listed in city directories from 1909 to 1910. Schiller Bros. also operated a distillery at 308 West Sixth Street and produced spirits such as Old Sunny Times Whiskey.

Opened in 1913, the Frank J. Quigg Brewery (1700 Madison) was listed as closed in the January 1915 issue of *American Brewers' Review*. Quigg appears to have operated Kansas City Bottling Company from 1914 to 1916 with J.R. Fairman at the same address.

According to city directories, German American Brewing Company (1605 West Sixteenth Street) operated from 1914 to 1916. Similarly named breweries also existed in Buffalo, New York, and in New Jersey.

1933: IMPERIAL BREWING COMPANY

This brewery (122 Southwest Boulevard) opened shortly after Prohibition ended. While it shared the same name as the much larger pre-Prohibition brewery in the Westside neighborhood, the two breweries had no connection. Joseph J. Goetz, secretary and treasurer, owned a 50 percent stake in the business. Brewery president Carl T. Stauch owned the other half of the brewery.

This version of Imperial Brewing brewed and sold Imperial Draught and Imperial Pale Ale. Initially, the beer was sold only in kegs and later in bottles after the brewery added a bottling department.

The company was sold to Griesedieck Bros. Brewing Company of St. Louis in 1938, and Imperial ceased operations. The brick building that housed the brewery is now painted green and is home to Finefolk, a women's clothing concept store and studio.

1935: MIDWEST BREWING COMPANY

Records show that Midwest Brewing Company (3028 East Eighteenth Street) was filed as a business entity with the State of Missouri on July 11, 1933. After conversion of the F.E. Ransom Coal & Grain Company, Midwest Brewing opened its brewery in October 1935 with an annual capacity of 73,000 barrels. Brewmaster Leo Wolf, former brewmaster at Muehlebach Brewing Company before Prohibition, brewed Midwest Pilsener, a kräusened beer that was aged sixty days before release and made with 100 percent malted barley. Kräusening, a process used in European breweries, adds active wort to beer being bottled and enables yeast to continue fermentation in the bottle. The method improves the beer's flavor by reducing diacetyl and acetaldehyde levels. The brewery closed in 1938 due to financial problems.

Chapter 6

Boulevard Brewing Company

Cabinetmaker and homebrewer John McDonald made his first test batches of pale ale in the late '80s. At the time, he was living in an apartment within an early 1900s-era brick building on Southwest Boulevard. McDonald was intrigued by the pale ale from Chico, California–based Sierra Nevada Brewing Company, founded in 1979. Sierra first released its pale ale in 1980, a hop-forward precursor to the West Coast style of brewing that helped launch the American craft beer movement. McDonald perfected his own recipe for a pale ale with a smooth balance between the bitterness of hops and malt. This flagship beer became the first cornerstone of Boulevard Brewing Company (2501 Southwest Boulevard, boulevard.com).

After raising $750,000 in investments, McDonald registered the business with the State of Missouri in September 1988 and assembled Kansas City's first new production brewery since Prohibition. Today, the original brewery, still housed in the old boiler room of that brick building, is part of a vastly larger modern campus. In the beginning, McDonald acquired a vintage Bavarian brewhouse and used equipment from a closed brewery in Bavaria, Germany. A fuzzy black-and-white photo circa 1989 showed McDonald and the brewery's first five employees: Harold "Trip" Hogue, Kent Foster, Kevin Fogarty, Beverly Ahern and an unidentified fifth person. Hogue, Boulevard's longest-tenured employee, helped to build the brewery's first bottling line when the instructions were in German.

Left: Trip Hogue, one of Boulevard's original five employees, tops off bottles on the bottling line. *Courtesy of Boulevard Brewing Company.*

Below: Boulevard Brewing founder John McDonald installs the brewery's first half barrel of pale ale at Ponak's on November 17, 1989. *Courtesy of Boulevard Brewing Company.*

On November 17, 1989, McDonald delivered the first half barrel of pale ale in the back of his pickup truck to Ponak's Mexican Kitchen & Bar located a few blocks from the brewery.

By the end of 1990, Boulevard had sold 1,742 barrels in its first full year of production. While Kansas City's beer drinkers were used to less expensive macro beers, primarily lagers, they purchased enough Boulevard craft beer on tap and in bottles to propel the brewery's sales upward. By 2002, Boulevard's annual sales amounted to 63,616 barrels.

What exactly is a microbrewery and craft brewer? According to the Brewers Association, an American craft brewer annually produces fewer than six million barrels of beer. A craft brewer is independent, meaning less than 25 percent of the brewery is owned or controlled by another member of the beverage alcohol industry that is not itself a craft brewer. Finally, a craft brewer uses traditional or innovative brewing ingredients to produce a majority of its total beverage alcohol volume.

The Brewers Association splits breweries into four segments: brewpubs, microbreweries, regional breweries and contract brewing companies. A microbrewery produces fewer than fifteen thousand barrels of beer per year with 75 percent or more of its beer sold off-site. Boulevard Brewing began as a microbrewery and grew to become a regional brewery when its annual beer production fell between fifteen thousand and six million barrels. By definition, volume and practice, Boulevard operates as a regional craft brewery.

Looking back, launching a microbrewery with a hop-forward pale ale was a calculated market risk. Boulevard's eventual success wasn't a foregone conclusion. The company had no readily available blueprint for guaranteed growth. "When we started, there were only around one hundred breweries in the entire country," McDonald said.

From the beginning, Boulevard was unconventional in distinguishing itself from other breweries. McDonald didn't see the need for traditional branding and marketing, especially with minimal funds to spend. Philosophically, marketing was a tactical effort applied more to sales support, such as creating tools for retailers, than brand development.

"Our branding would be called guerrilla marketing now—painting our logo on the side of buildings, giving away T-shirts at events and offering samples," said Jeremy Ragonese, Boulevard's director of marketing since 2006.

Boulevard hired Bill Cherry, a microbiologist with a food science background, as its first head brewer. Cherry studied at University of California–Davis and graduated from the brewery program in a class of

Founder John McDonald during Boulevard Brewing's earliest days. *Courtesy of Boulevard Brewing Company.*

ten people. When Cherry left in the mid-'90s, McDonald carefully selected his future brewmaster. While scouting brewing equipment in Europe, McDonald expanded his personnel search beyond the States.

"I looked all over the world for the right guy," he said. "We advertised in U.S., German and Belgian brewing schools. I interviewed several brewers while in Europe."

McDonald had returned to the United States when he first connected by fax with Steven Pauwels. A Belgian brewer with a biochemical engineering degree, Pauwels had worked at Brouwerij Krüger and a brewpub in Louvain, Belgium. McDonald initially interviewed Pauwels over the phone and then flew him to the United States over Super Bowl weekend in 1999 for an interview.

"I sat in a room with other brewers. They shot all types of technical questions at me," Pauwels said. "I had never really encountered that in Belgium, where brewing is just a job. These guys had passion and wanted to make better beer. They were eager to learn. That eagerness never went away."

Pauwels has remained the brewmaster since 1999 and led the company's brewing operations and brewing team. His impact was immediate.

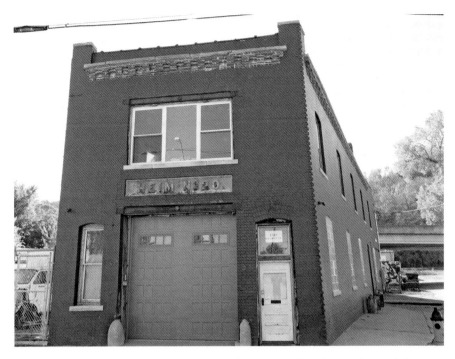

Above: Ferd Heim Brewing Company No. 20 firehouse, one of the brewery's remaining buildings in the East Bottoms. *Photograph by Pete Dulin.*

Below: Imperial Brewing Company operated pre-Prohibition. The historic building in the Westside neighborhood is visible from I-35 Highway and Southwest Boulevard. *Photograph by Pete Dulin.*

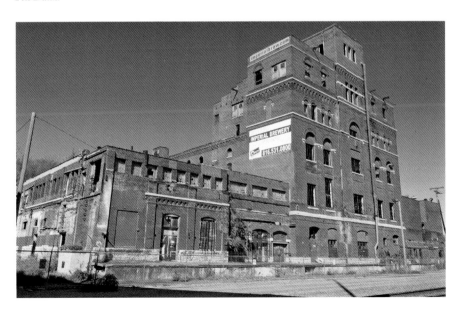

Above: A second version of Imperial Brewing Company at 122 Southwest Boulevard opened post-Prohibition. The building is now home to clothing retailer Finefolk. *Photograph by Pete Dulin.*

Below: James Flanagan's saloon (1724 West Ninth Street and State Line) and more than twenty pre-Prohibition taverns flowed with booze on the "Wettest Block in the World." *Photograph by Pete Dulin.*

Above: Pabst Brewing built a depot at 2101 and 2107 Central in 1910. Boss Tom Pendergast bought both buildings in 1920 after Prohibition began. He used the former building as the T.J. Pendergast Wholesale Liquor warehouse. *Photograph by Pete Dulin.*

Below: An advertising image for several brands of Goetz beer. *Courtesy of the Jackson County Historical Society Archives.*

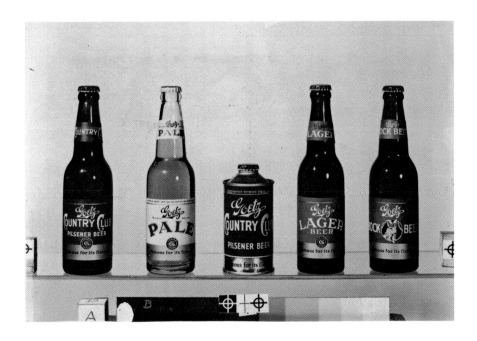

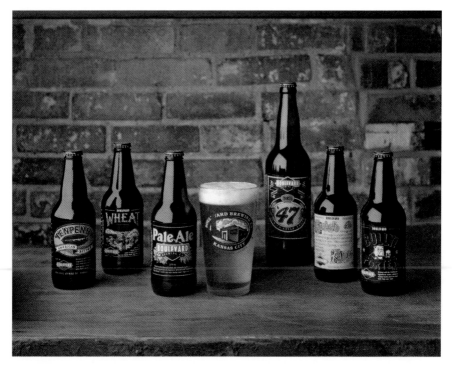

Above: Boulevard Brewing Company beer brands, circa 1995. *Courtesy of Boulevard Brewing Company.*

Below: Boulevard Brewing Company exterior with the iconic Boulevard smokestack, circa 2014. *Courtesy of Boulevard Brewing Company.*

Above: An artist's rendering of the Boulevard Brewing Company visitor center scheduled to open next to the brewery in the summer of 2016. *Courtesy of Boulevard Brewing Company.*

Below: Amerisports Brew Pub brewmaster Stacey Payne at the brewhouse control panel. The fifty-barrel brewhouse is clad entirely in copper. *Photograph by Pete Dulin.*

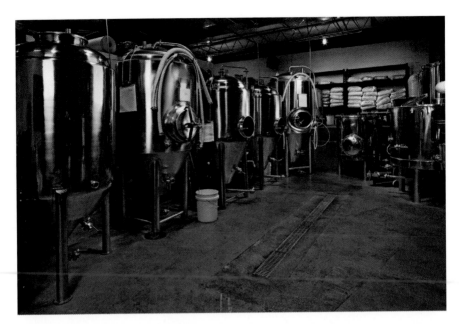

Above: The Big Rip Brewing Company's tanks—Ash, Krueger, Mulder, Ripley and Vader—are named after sci-fi and horror characters. *Photograph by William Hess, courtesy of the Big Rip Brewing Company.*

Below: The Big Rip Brewing Company's Aisle 12 West Coast IPA in the taproom. *Photograph by William Hess, courtesy of the Big Rip Brewing Company.*

Above: Cinder Block Brewery brewmaster Bryan "Bucky" Buckingham at the taproom bar. *Photograph by Pete Dulin.*

Below: John Baikie (*left*) and Cinder Block Brewery founder Bryce Schaffter oversee a brew on the pilot system. *Photograph by Pete Dulin.*

Above: Overland Park Brewing mug, circa 1995. *Courtesy of Robert Adams.*

Below: Torn Label Brewing Company's brewhouse in the East Crossroads Arts District. *Courtesy of Torn Label Brewing Company.*

Above: The name and logo of Rock & Run Brewery and Pub reflects the marathon running and music interests of its owners in addition to beer. *Photograph by Pete Dulin.*

Below: Crane Brewing Company. *Front row*: Christopher Meyers, Michael Crane, Steve Hood and Jason Louk. *Back row*: Aaron Bryant and Randy Strange. *Photograph by Chris Mullins, courtesy of Crane Brewing.*

Above: A flight of Red Crow Brewing Company's beers on the patio. The beers are named after influential women in the lives of the brewery's founders. *Photograph by Pete Dulin.*

Below: Brewery Emperial co-founders Julie Thompson, Keith Thompson, Rich Kasyjanski and Ted Habiger in front of the future brewhouse, circa 2016. *Photograph by Pete Dulin.*

Above: The construction site for Brewery Emperial at 1829 Oak Street, January 29, 2016. *Photograph by Pete Dulin.*

Below: Brendan Gargano (*left*), Greg Bland and Ray Kerzner (not pictured) co-founded Stockyards Brewing Company, which opened in 2016 in the original Golden Ox restaurant. *Photograph by Pete Dulin.*

Above: Martin City Brewing Company assistant brewer Grant Bergmann, co-founder Matt Moore, co-founder Chancie Adams and brewmaster Nick Vaughn. *Photograph by Pete Dulin.*

Below: Muehlebach glassware displays the signature name and Swiss cross in the logo. *Photograph by Pete Dulin.*

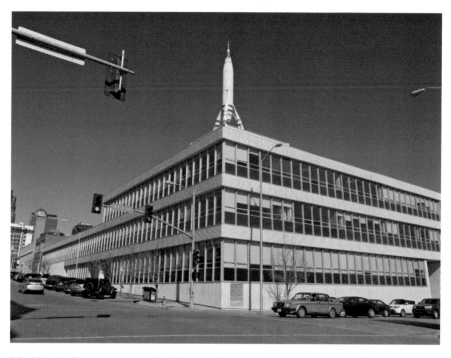

Muehlebach Brewery's original building at Eighteenth and Main was demolished in 1941. The TWA building that replaced it is now home to advertising agency Barkley. *Photograph by Pete Dulin.*

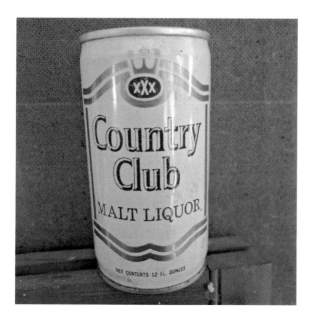

An antique can of Country Club Malt Liquor from Goetz Brewing Company. *Photograph by Pete Dulin.*

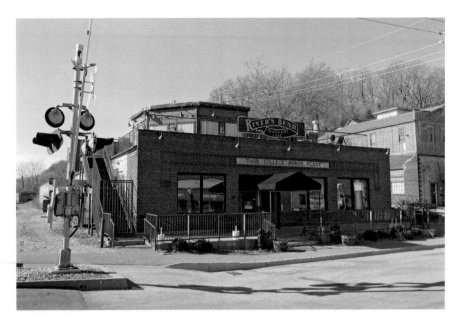

Above: The Park College Power Plant was once home to Power Plant Brewing Company and later River's Bend Restaurant in Parkville, Missouri. *Photograph by Pete Dulin.*

Below: Kansas City Bier Company's massive brewhouse is filled with giant vessels. It is the second-largest brewery by annual volume in Kansas City after Boulevard Brewing Company. *Photograph by Pete Dulin.*

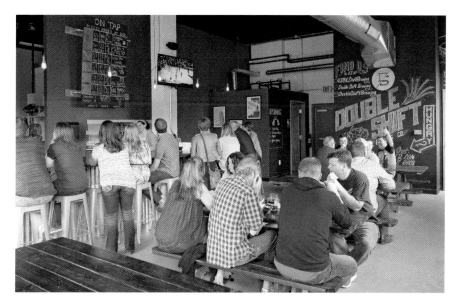

Above: Double Shift Brewing Company's busy taproom on weekends is one of several located on Brewery Row, East Eighteenth Street in the Crossroads Arts District. *Photograph by Pete Dulin.*

Below: Brewer Stacey Payne in the copper-clad brewhouse of Amerisports Brew Pub. *Photograph by Pete Dulin.*

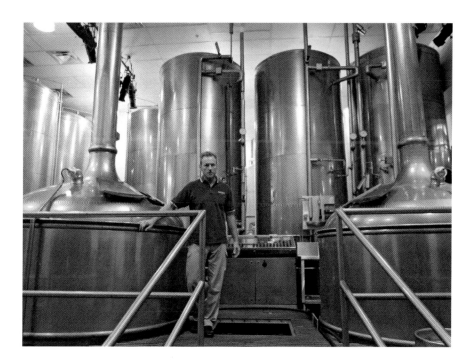

Above: Custom tap handles made from railroad spikes highlight Martin City Brewing Company's logo, the brewery's proximity to a railroad line and the city's historic ties to the Kansas City, Pittsburgh & Gulf Railroad. *Photograph by Pete Dulin.*

Below: This preserved stained-glass window, one of the many signature features of the historic Golden Ox steakhouse, is a colorful feature in the Stockyards Brewing Company event space that connects past to present. *Photograph by Pete Dulin.*

In 1990, Boulevard added Filtered Wheat, a citrusy, American-style wheat that differed from the banana and clove profile of German hefeweizen. The brewery introduced an Unfiltered Wheat version in 1994 available only on draft that began outselling the filtered original. After McDonald purchased a centrifuge in 1999, Pauwels led development of Unfiltered Wheat for packaging in bottles. Sales of Unfiltered Wheat soared due to its natural citrus flavor, distinctive cloudy appearance and accessibility in bottles, available a decade after the original version of the beer debuted.

"In our first few years, we almost doubled our business every year. In 1995 or 1996, the craft beer industry went from 20 to 30 percent growth to 1 percent growth. Some of our fastest growth was from 1996 to 2000," McDonald said. Boulevard's location in the Midwest and popularity of its Unfiltered Wheat fostered that growth. "It was a beer that hit a chord in the central Midwest because of the agricultural heritage here. It was unusual because it was cloudy and was a great, drinkable beer."

Today, Unfiltered Wheat accounts for half of the brewery's production. It is the number one craft beer in five states, including Missouri and

Trip Hogue (*right*) and another employee on Boulevard's bottling line, circa 1992. *Courtesy of Boulevard Brewing Company.*

Kansas. Also, Unfiltered Wheat is now the best-selling craft beer of its style throughout Boulevard's selling region.

Neil Witte, a former assistant brewer at several KC Hopps brewpubs, began his career at Boulevard in 1997 as a brewer. From 2000 to 2013, Witte's role focused on field quality and training, where he managed quality control issues with Boulevard's distributor and retail partners. Witte helped to improve the conditions where Boulevard's beer was delivered, stored, sold and consumed. He trained professionals in the beer and service industry professionals, as well as Boulevard staff, on draught systems, maintenance, troubleshooting, beer knowledge and service. The end goal was to maximize the customer's beer drinking experience. Since 2014, Witte has continued to provide beer training and education for employees of Boulevard's parent company, Duvel Moortgat USA, distributors and retail partners.

Jennifer Helber, a UMKC microbiology graduate student in 1989, started the brewery's first yeast propagation after McDonald approached her professor, Dr. Rona Hirsberg, about cultivating yeast. Ten years later, Helber answered a Boulevard advertisement and was hired by McDonald to help develop Boulevard's quality-assurance laboratory. Helber spent nine years tasting the brewery's beers regularly each day to assess and ensure each beer had the desired flavor and aroma characteristics. She tested pH levels, established the quality assurance program and started the tasting program. Helber now owns and operates Grain to Glass, a homebrew supply shop and craft beer bar that hosts classes and events.

Other microbreweries entered the market and vanished during the '90s because of poor quality, branding, financing or other factors. Macro brewers competed by introducing their version of "craft beers." Consumers were confused or apprehensive about craft breweries and beer brands with inconsistent quality and misleading marketing.

Within that volatile environment, Boulevard focused on production, quality and distribution to its "hometown" audience for the first eight years. The brewery developed a trusted brand. Boulevard "earned the right to sell elsewhere" across the region, according to McDonald.

Boulevard adopted a regional strategy "that worked well due to lack of competition in Omaha, Tulsa, Columbia and other locales," McDonald said. "Now, there's more competition where we're no longer the local beer."

Nonetheless, Boulevard continued to sell large volume in regional markets. Growth eventually began to slow and necessitated another strategic shift. Knowing it made great beer, the company realized it should

be able to sell in a bigger context. It introduced the Smokestack Series in 2007 and competed for the high-end segment in the United States.

"We launched four Smokestack beers in 750-milliliter bottles. We quickly became a leader with that series in the state. Name recognition started getting out," Ragonese said. "We branded it away from the core [beers] because people associated Boulevard as a little brewery in the Midwest that made good wheat beer. This was not that."

Boulevard didn't yet have craft beer consumers on the coasts to drive momentum. "We needed people to take a second look," Ragonese said. "We introduced something as part of our brand that was a departure. When we started telling the story behind the Smokestack Series, it worked."

The change in packaging, emphasis on the series' name and bold, high-quality beers helped Boulevard attract craft beer fans nationwide. Ragonese acknowledged that "Smokestack became a growth engine the likes of which Boulevard hadn't seen in a while. Tank 7 was a surprise hit." By year-end 2007, Boulevard distributed its beers in a thirteen-state region, primarily throughout the Midwest, upper Midwest and Texas.

National consumer demand grew for craft beer in the early twenty-first century. Supply-wise, growth in the number of new breweries was sluggish from 2000 to 2008, prior to the Great Recession. However, a wave of craft brewing arrived even as the United States was in deep economic recovery. In 2008, the Brewers Association recorded a combined 1,521 craft brewpubs, microbreweries and regional breweries. By November 2015, that number swelled to 4,144 breweries in the United States and topped the historic high of 4,131 U.S. breweries in 1873.

During the 2008 financial crisis and recovery, Boulevard's draft beer business shifted overnight from 50 to 40 percent while its packaged beer increased to 60 percent. Consumers drank beer at home rather than at bars and restaurants. McDonald said that the financial crisis "scared a lot of people and got people to change habits and save money."

Meanwhile, Boulevard invested in its operations as the market grew crowded. The brewery underwent expansions in 1999 ($2.5 million completion of Cellar Two) and 2003 ($1.3 million completion of Cellar Three) to add production capacity. Boulevard broke ground in March 2005 on a $25 million expansion that opened in September 2006 and further increased production capacity to its current level, approximately 600,000 barrels per year. Jumping ahead in time, its 2015 sales amounted to 196,962 barrels. Comparatively, Muehlebach Brewing Company reached a high point in 1947 with sales of 244,000 barrels and increased

Boulevard's modern automated bottling line, circa 2016. *Courtesy of Boulevard Brewing Company.*

its production capacity in 1951 to 500,000 barrels, according to figures cited in *Hometown Beer*. In other words, Boulevard's sales and production capacity approached historic proportions in Kansas City.

Adjacent to Boulevard's original building, the three-story, seventy-thousand-square-foot brewing and packaging facility houses a 150-barrel brewhouse, packaging lines, administrative offices and hospitality rooms. On September 14, 2006, exactly seventeen years to the day that Boulevard produced its first bottle of pale ale, former Kansas City mayor Richard Berkley cut the ribbon to open the facility. Mayor Berkley also capped the first keg of Boulevard beer in November 1989.

Boulevard's capacity for fermentation also needed upgrading. In January 2010, the brewery announced installation of three new 600-barrel fermentation tanks. Eighteen months later, Boulevard revealed plans for a $3 million remodel of the old brewhouse and the addition of eight 300-barrel fermentation tanks. Boulevard also broke ground in November 2014 on its Cellar Five expansion, a $12 million project that was completed in February 2016. The project entailed construction of a wastewater treatment facility and a 3,600-square-foot building that houses

six 1,000-barrel fermenting tanks. The addition boosted fermentation capacity to more than 300,000 barrels of beer. The building has space for another six fermentation tanks to accommodate future growth.

The expansions boosted Boulevard's capacity to brew Unfiltered Wheat and pale ale, which together composed more than 60 percent of Boulevard's sales by 2006. Pauwels and the team of brewers also had more elbow room to develop new beers. Boulevard introduced Lunar Ale, an unfiltered brown ale with Belgian yeast, in March 2007, its first new year-round beer since 1996. The beer was later discontinued.

The Smokestack Series expanded into a line of year-round, seasonal and limited-edition beers packaged mostly in 750-milliliter bottles. Some selections are also available in twelve-ounce bottle format and on draft. These artisan beers are typified by higher alcohol content and Belgian influences with most styles in the series.

"We wanted to come out with the Smokestack Series for ten years. We just didn't have capacity," McDonald said. "When we built this [new brewery], we unleashed the dogs. We have one of the most vibrant, high-end specialty beer niches in the craft beer industry led by Tank 7."

Tank 7 is named after fermenter number seven, a fickle piece of equipment used by the brewers to develop an unprecedented variation on a traditional Belgian-style farmhouse ale. Tank 7 is the bestseller in the Smokestack Series. Smokestack's other year-round beers include The Calling Double IPA, Long Strange Tripel, The Sixth Glass Quadrupel, Dark Truth Stout and Tell-Tale Tart.

Pauwels observed that newer breweries don't necessarily have flagships and that brewing today is a process of "constant development."

Astutely, Boulevard has steadily added more beers to its overall roster. Boulevard Pilsner debuted in 2009. This classic American lager was inspired by the history of local brewing, particularly the George Muehlebach Brewing Company. Its name was changed in 2013 to KC Pils.

India pale ales (IPAs) accounted for less than 8 percent of the craft category circa 2008 in terms of industry-wide volume produced, reported Chief Economist Bart Watson for the Brewers Association. By August 2015, the volume of IPA produced industry-wide leaped to 27.4 percent, with more anticipated growth by year-end. Boulevard's rollout of Heavy Lifting IPA, Single-Wide IPA and Pop-Up Session IPA (renamed in 2016 as Frequent Flier Session IPA) rounded out its portfolio in the category.

Ginger Lemon Radler, Hibiscus Gose, Early Riser Coffee Porter and other entrants bolstered the classic line of seasonals such as Irish Ale,

Nutcracker Ale and Bob's '47 Oktoberfest. The latter Munich-style lager was introduced in October 1993 and named for Bob Werkowitch, master brewer and graduate of the U.S. Brewer's Academy in 1947.

Boulevard's annual slate of limited releases include its barrel-aged wild ale Love Child series, Chocolate Ale, Bourbon Barrel Quad, Rye on Rye, Saison-Brett, Imperial Stout X series and Collaboration series. The Tasting Room series put experimental beers on tap in Boulevard's tasting room and limited rotation of some styles in bottles. The brewery gathers feedback from the public and its employees on these beers. Ginger Lemon Radler is one such beer that became a seasonal offering.

In 2014, Boulevard Brewing joined Belgian brewery Duvel Moortgat's family of breweries. The acquisition marked a twenty-five-year evolution from a startup brewery to a regional craft brewery to a globe-spanning partner with vast potential. The initial reaction from Boulevard's Kansas City fans was mixed but supportive overall.

"I believed people would trust us to do the right thing," McDonald said of the difficult decision. "That was my best choice to do the best thing for the brewery, my family, Kansas City and our customers."

Duvel's U.S.-based operations also include Cooperstown, New York–based Brewery Ommegang, acquired in 2003, and the 2015 purchase of Paso Robles, California–based Firestone Walker. McDonald retained part ownership of the company he founded. Boulevard continues to operate in Kansas City. With greater resources, the brewery has reached new U.S and international customers and markets while retaining its local focus.

Boulevard is Missouri's second-largest brewery and the eighth largest craft brewery in the United States. Those rankings are based on combined U.S. sales with Brewery Ommegang and Duvel imports, per figures from the Brewers Association.

The company commemorated its twenty-fifth anniversary in 2014 with the release of Silver Anniversary Ale. The American Strong Ale was made in collaboration with Odell Brewing, which opened on November 18, 1989, a day after Boulevard opened its doors. The breweries created and released two versions of the ale with a shared split-label design on the 750-milliliter bottle.

In June 2014, Boulevard attracted thousands of people to its first urban street festival, dubbed Boulevardia, in the West Bottoms. The three-day annual family-friendly event on Father's Day weekend combined craft beer, food trucks, local and national music acts, Makers Village and a carnival.

John McDonald at the inaugural Boulevardia festival in the West Bottoms, circa 2014. *Photograph by Pete Dulin.*

In December 2015, Boulevard announced a long-term lease for a new distribution center in south Kansas City. The 364,000-square-foot building in the Three Trails Industrial Park provided Boulevard with three times more warehouse space than its East Bottoms facility. The brewery planned to house its finished beer ready for distribution, plus a barrel-aging cellar and bottling line for its Smokestack Series.

Other developments included the roll-out of canned versions of Unfiltered Wheat, Frequent Flier, Ginger Lemon Radler and Heavy Lifting, a new IPA. Canned beers are contract brewed and packaged by Third Street Brewhouse in Cold Spring, Minnesota, using its equipment until Boulevard installs a canning line on site. The release of Crown Town Ale celebrated the Kansas City Royals' 2015 World Series victory. Previously, Boulevard had honored Sporting KC's 2013 MLS Cup championship with a 2014 limited-edition Championship Ale.

Boulevard Brewing introduced a new company logo and branding in 2016 that extended to its beer packaging. The updated look of its cans, labels and packaging conveys a bold, streamlined graphic presentation. The redesign utilizes a simpler color scheme, distinct imagery and patterns to refresh its look while reinforcing the unity and lineage of the brewery's identity dating back to the company's inception.

Creative director Payton Kelly designed the brewery's first labels and other artwork as a freelancer until 1995, when he joined Boulevard as a full-time employee. "A lot of development of the brand portfolio was relatively unguided," said Kelly of Boulevard's early look.

The identity of the Smokestack Series evolved as its brand grew in prominence. "Smokestack was, by design and development, not looking much like our family of beers," Kelly said. "We planned it to mask the Boulevard brand. The fear was that we'd cannibalize our core customers."

Boulevard realized instead "that it was more beneficial to have the Smokestack experience and quickly associate it with Boulevard," according to Kelly. The redesign made "a more coherent, recognizable family of beers."

In other words, Boulevard wanted customers nationwide to enjoy a Tank 7, for example, and quickly connect the dots back to the brewery and its other beers.

"The strategic approach of letting each brand run with its own story and look worked locally," Kelly said. "However, it was hard for people elsewhere to deconstruct and understand in other markets. Nationally, Boulevard didn't have the built-in recognition or cultural understanding that it had in its hometown market."

The contemporary design direction created a stronger sense of unity and continuity to aid consumers in all markets.

The brewery shared plans in 2016 to open a visitor center in a four-story building at 2534 Madison adjacent to the brewery. Originally built in 1929 for the Skelly Oil Company, the red brick building houses the visitor center on the lower two levels. The center includes an Experience area with exhibits, expanded retail shop and expanded tasting room. A beer hall occupies the ten-thousand-square-foot second floor and features Boulevard's beers and limited food. Headed by Boulevard's new Tours & Recreation Department, the brewery's new center expands its capacity to host more people and tours. In 2015, Boulevard hosted nearly sixty thousand visitors on approximately 2,300 tours and was unable to accommodate thousands more due to lack of space.

By the spring of 2016, Boulevard Brewing has completed agreements with distributors to sell its beer in thirty-five states and the District of Columbia. Tank 7, Single-wide IPA and other Boulevard beers are also distributed in France, Belgium, the Netherlands, the United Kingdom and China.

Boulevard has actively supported local charitable giving and community improvement. For instance, Boulevard's founder and president, John McDonald; chief financial officer Jeff Krum; and plant engineer Mike Utz teamed up in 2009 with local companies DST Systems, Inc. and UMB Financial Corp. to form Ripple Glass. Ripple Glass constructed a state-of-the-art processing plant. It also placed dedicated glass recycling containers throughout the city to collect tons of glass each year once destined for landfills. Nearly 20 percent of Kansas City's container glass is recycled and processed by Ripple Glass for reuse.

Boulevard's impact on Kansas City's modern brewing industry is difficult to overstate. The company grew from a handful of people to 126 full-time employees in 2016. Led by McDonald's drive to make good beer, Boulevard launched a craft brewing renaissance in Kansas City that gradually encompassed the Midwest.

"Probably the biggest decision we made, and I still think it is the right one, was to stay here," McDonald said. "Most modern breweries aren't choosing inner-city locations."

Facing the reality of more competition, McDonald commented on the current craft brewing landscape. "I think it's wonderful that there are four thousand breweries in the U.S.," he said. "I think the production of local things that people support is key to a happy, healthy life and a good society. We're a global society today. Some companies are getting bigger like banks and global breweries. I'm a real believer that decentralization in this industry is healthy. The winners will be people that have great reputations and make the best beers. We built a great brewery that people have regards for. We exemplify the craft beer segment."

Casting a glance at the future, McDonald saw signs of old patterns. "There's a little bit of people getting into the business again for the wrong reasons like in the early '90s. A lot of people see big dollar signs," McDonald said. "That's not healthy for the business, but there's a lot more good than there is bad going on. Brewing won't go back to three giant breweries in the U.S. There will be room for people with good ideas. There's a lot of opportunity in the business."

Brewpubs and Breweries in the 1990s

1993: 75ᵀᴴ Street Brewery

75th Street Brewery (520 West Seventy-fifth Street) was the first and longest-operating brewpub in Kansas City. Owned by parent company KC Hopps, Ltd., the brewpub concept fit well with the density of residents and local businesses in the Waldo neighborhood. The brewpub combined the family-friendly feel and casual upscale food of a restaurant with an American spin on a European pub. Brewpubs, where beer is brewed on site and the brewhouse is typically on view, became a popular model in Greater Kansas City during the 1990s.

Boulevard Brewing and Free State Brewing in Lawrence, Kansas, demonstrated that fresh, high-quality beer could be made by a local brewery. 75th Street Brewery offered a setting to enjoy beer at a bar only a few feet from where it was brewed.

Royal Raspberry Wheat won a bronze medal at the 1995 Great American Beer Festival. Muddy Mo' Stout, Good Hope IPA, Cowtown Wheat and scores of other beer styles have been brewed and offered on tap. Since inception, the brewpub has earned five awards, including a gold medal at the World Beer Cup and Gold in the 2004 Great American Beer Festival for Fountain City Irish Red.

Six flagships and up to three seasonals were on tap at any given time. The recipes of the flagship beers changed over the years, but each beer retained characteristics of its style. The brewery distributed its beers only to

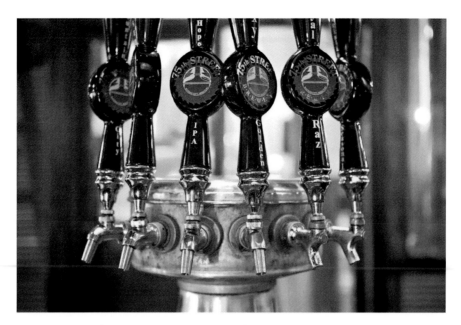

Tap handles at 75th Street Brewery. *Courtesy of 75th Street Brewery.*

sister restaurants in the KC Hopps family. By volume, 75th Street Brewery produced 1,080 barrels in 2013. Annually, production fell between 1,000 and 1,500 barrels.

Many of Kansas City's brewers had worked at 75th Street at some point in their career, including Keith Thompson (McCoy's Public House, Brewery Emperial), Pat Sandman (Calibration Brewing), Micah Weichert (Gordon Biersch, Stockyards Brewing Company), Nick Vaughn (Martin City Brewing Company) and Bryan Buckingham (Cinder Block Brewery).

Joyce Smith, business writer for the *Kansas City Star*, reported on March 3, 2016, that KC Hopps, Ltd. listed the brewery for sale. The listing indicated that the brewery was profitable for twenty-two years in a row. Gross income was listed at $1.95 million. The asking price of $690,000 included furniture, fixtures and equipment. KC Hopps sought to sell the local "institution" so that the restaurant group could focus on its other brands.

Writer Charles Feruzza of *The Pitch* reported on March 29, 2016, that Chef Domhnall Molloy and general manager Andy Lock, owners of Summit Grill & Bar in Waldo, were completing their purchase of the brewpub in late March. They planned to move Summit Grill into the completely renovated space, effectively ending 75th Street's run as a brewery and concluding a significant chapter in Kansas City's brewing history.

1993: Saddle Sore Brewing Company

Formed as a business entity on August 9, 1993, by accountant Bruce Swabb, Saddle Sore Brewing (11924 West 119th Street) in Overland Park only lasted seven months. The brewery later became a Barley's Brewhaus location.

1994: Westport Brewing Company

Westport Brewing Company (4057 Pennsylvania) lasted between one and two years. The business was registered with the State of Missouri on March 30, 1994, by lawyer Charles P. Schleicher. Walter C. Janes owned the brewery. Schleicher and Janes were enmeshed in a racketeering scandal tied to J.C. Nichols Company and monies behind Westport Brewing.

According to an Associated Press story dated October 4, 2001, former J.C. Nichols Company chief financial officer, vice-president and treasurer Walter C. Janes pleaded guilty to stealing more than $150 million from his employer. Janes, Lynn L. McCarthy and attorney Charles P. Schleicher, all former executives of the company, were indicted in February 2001 on racketeering and related charges for thefts from J.C. Nichols Company between 1987 and 1995. Among the alleged charges that involved movement of company funds to personal accounts and acquisition of stock, Janes orchestrated use of $1.1 million in Nichols's checks between 1994 and 1995 for the establishment and operation of his personal business, Westport Brewing Company.

Janes and McCarthy, the former chairman, president and CEO of J.C. Nichols Company, pleaded guilty to the racketeering conspiracy charge. They each received five years of probation for stealing and defrauding the company from 1986 through 1995, reported the *Kansas City Business Journal*. Schleicher was acquitted of charges in November 2001.

A filing dated September 30, 1996, by J.C. Nichols Company and listed on Securities Information's database revealed details of the settlement of claims against Janes. The document showed that "the adjusted outstanding balance on the debt incurred by Westport Brewing Co., Inc. (*'Westport Brewing'*), in the total amount of $1,161,845, shall be consolidated and evidenced by a new promissory note, with an effective date of July 1, 1995." The settlement listed payment and terms of interest. Also, it specified, "The note shall be secured by all assets, including the leasehold interest, of Westport Brewing."

By 1996, Westport Brewing had ended its short-lived run. Brewery equipment was dismantled and removed, likely to be sold in order to repay debt. The property remained vacant for a time. Another brewpub, McCoy's Public House, emerged in the space in early 1997. Neil Witte, currently a training and technical support manager at Duvel USA, Boulevard Brewing Company and Brewery Ommegang, moved to Kansas City to begin his first brewing job as assistant to head brewer Keith Thompson at McCoy's.

"I started with KC Hopps (they were original investors in McCoy's) in April 1997. I ripped out dining room and kitchen equipment that had been there for a while," Witte stated, recalling the brewpub transition. "Everyone talked about that space being cursed because nothing could stay in business there. I also remember people being surprised that it sat empty as long as it did because, despite the 'curse,' it was a prime spot."

Since 1997, McCoy's Public House has endured as a mainstay in Kansas City's brewing community and as a prime destination in Westport.

1994: MILL CREEK BREWERY AND RESTAURANT

Mill Creek Brewery (4050 Pennsylvania Avenue) opened in 1994 and closed in 2002. The brewery was co-owned by Jerry Arnoldy; Kyle Kelly, current co-owner of Kelly's Westport Inn; Jim Aylward; and Bruce Vance, who owns Buzzard Beach in Westport.

The owners conducted research on brewpubs across the country before creating their own version. Kelly recalled asking Boulevard Brewing Company founder John McDonald about brewpub owners to contact. McDonald recommended they contact John Hickenlooper, who had a stake in Denver-based Wynkoop Brewery, Colorado's first brewpub. Kelly and others visited numerous breweries in Colorado. Wynkoop proved to be a good business model that provided billiards and parlor games to entertain patrons as they drank beer.

Wynkoop Brewery invested in Mill Creek Brewery and owned a 20 percent stake in the business, Kelly stated. When Hickenlooper came to Westport to inspect the district, he told Kelly that there wasn't anything for people to do but drink. Duly noted, Mill Creek Brewery offered pool, darts, other entertainment and a restaurant.

Notably, Hickenlooper went on to become mayor of Denver (2003–11) and has been governor of Colorado since 2011.

The ten-thousand-square-foot Mill Creek Brewery was located in the former Old Colony Steakhouse. The brewery's slogan was "Great Food. Fresh Beer. Amen." The slogan was coupled with an Omni award–winning logo design of a brewer in an apron as he hoisted a pilsner glass in the air and inspected its contents.

Mill Creek's beers included Forty Acre Wheat, Real McCoy Amber and Tinkers Irish Stout. The brewery also released a 4:20 Hemp Ale, made with hemp seeds without THC, the chemical compound that gives marijuana its appeal. A promotional T-shirt for Hemp Ale touts slang from the era: "Don't Bogart that Beer."

Brewery consultant Jim Lueders, who earned a master's degree in brewing technology in Munich, Germany, helped to set up Mill Creek's brewery. The fifteen-barrel brewhouse had four fifteen-barrel fermenters and four fifteen-barrel serving tanks.

John Jordan, who assisted Lueders with brewing batches, allegedly became the head brewer at Mill Creek shortly afterward. The recollection of former Mill Creek brewer Rob Dewar and Kyle Kelly are fuzzy on this point. A *Lawrence Journal-World* article dated November 1, 1995, identified Jordan as the current head brewer. The article also stated that when Lueders headed to St. Louis next to help set up Morgan Street Brewery, the head brewer at Mill Creek followed and Jordan succeeded that person. Dewar recalled that

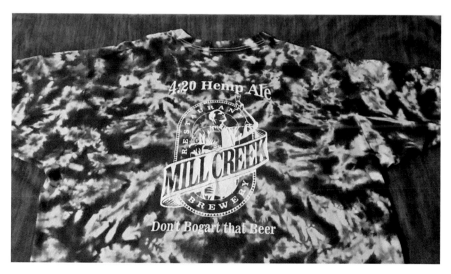

A tie-dye T-shirt for Mill Creek Brewing Company's Hemp Ale. *Courtesy of Robert Dewar.*

Stan Robinson, a medical student, was an assistant brewer and bartender for several years.

Jordan went to Flying Monkey to be its head brewer around 1995 or 1996, Dewar stated. That timing would put Jordan at Flying Monkey's Merriam brewhouse when the company launched.

Dewar started homebrewing in 1993 in Missoula, Montana. In 1994, he interned and did lab work for Bavarian brewer Jurgen Knoller at Bayern Brewing, also based in Missoula. Lueders was one of Knoller's first assistant brewers. Dewar became a full-time brewer and part-time lab technician that year. He received a call in January 1997 from Lueders regarding an opening at Mill Creek. Dewar accepted the position, moved to Kansas City and worked at Mill Creek from January 1997 to October 2000. Afterward, Mike McMahon, a brewer from Sports Page Brewing, took over brewing duties.

"I tweaked all of the [Mill Creek] recipes; however, it was the stout that received most of my attention," Dewar said. "I completely revamped it, added nitrogen and altered the malt and hop profiles. After two and a half years of experimenting, I took the best version to the 1999 Oregon Brewer's festival in Portland, where it was the fourth beer of seventy-two to sell out."

According to Dewar, one of Mill Creek's owners offered to sell him the business in 1999. "I had several local doctors who were also homebrewers lined up to invest," Dewar said. "However, I decided that I wanted to live out West and never pursued that option."

Dewar sought financing in early 2016 for a five-thousand-square-foot brewpub in Tempe, Arizona, called Local Route Brewing Company. The brewery's logo features the bus Dewar bought in Kansas City to drive to Big Sky, Montana, where he lived next. Dewar hopes to open this brewery in the spring of 2017.

Several factors contributed to the demise of Mill Creek Brewery. "The location was set back from Westport Road. It didn't get enough foot traffic," said Kelly. "It was a big place. The spacious kitchen, storage and offices took about 37 percent of the total space. Normally, the back office and kitchen would be 20 percent."

The large space came with a hefty monthly lease. Competition was likely a factor as well. Less than a block away, short-lived Westport Brewing Company launched in 1994 and its successor, McCoy's Public House, opened in 1997. Staff changes for the head brewer and assistant brewer positions may have impacted consistency of the beer quality, as a few online reviews from 2002–3 suggested.

Another issue that likely affected Mill Creek Brewery and Westport at large was growing crowds of underage teenagers in the summer who roamed the entertainment district late at night. The crowds drove away older patrons and reduced foot traffic to area businesses.

In an Associated Press story dated August 18, 2002, Arnoldy said, "Business is off from three years ago at least 30 percent. I'd guess a lot of people down here are hanging by a thread."

Kyle summed up the brewery's closing by stating that there weren't "enough up years to offset the down years."

In the decade-plus since, curfews have been enforced, security and police presence have increased and other measures were taken to reinforce the safety and appeal of Westport as a dining, drinking and entertainment destination.

1995: River Market Brewing Company

Chief executive officer and managing partner Steve Palmer raised enough capital in 1994 to begin developing River Market Brewing Company (500 Walnut). He also launched Power Plant Restaurant and Brewery in Parkville five years later.

Palmer, a homebrewer, decided to change his career. General Motors shifted production jobs to Mexico in the early 1990s. Palmer, a production manager at the local plant, explained to his wife that he wanted to start his own company rather than find another job.

"We agreed that we were young and could probably withstand any misfortune that might come our way, so she gave me her blessing," Palmer said. "I learned all I could about creating a brewpub and restaurants in general while formulating my vision and writing my business plan."

Palmer studied Northland locations of the former Kerry Patch, Old Firehouse and Park College power plant in Parkville as potential sites. He decided that even if the power plant's four large boilers were removed, the building still wouldn't have enough space for a brewery and restaurant. He settled on the former Grandma's Pie Pantry, a corner restaurant in the River Market's historic Gillis Opera House building. The basement had ample space to store grain, hops and an icehouse.

During the mid-1990s, the historic River Market experienced growth. Residents were drawn to new River Market lofts built by developers and weekend activity in the City Market. French bistro Le Fou Frog opened

in 1996, one block east of the City Market. A brewpub only added to the area's appeal.

Palmer visited Free State Brewing Company, which opened in 1989 in Lawrence, Kansas, and also researched two breweries in Tulsa, Oklahoma. He also visited Steamboat Brewery in Steamboat Springs, Colorado, where he met Artie Tafoya, a veteran award-winning brewer at the Great American Beer Festival. Palmer brewed a couple batches of beer with Tafoya and later hired him as a consultant to help choose suitable brewing equipment and refine homebrew recipes for mass consumption. While Palmer's business plan was in development, 75th Street Brewery opened in 1993 as Kansas City's first brewpub.

Palmer, who was River Market's initial head brewer, trained server Brian Reinecke in the craft of brewing. Reinecke worked as head brewer from 1996 to 2001, when he left to work at a brewpub in Boulder, Colorado. Palmer resumed brewing duties until he sold his interest in 2002.

Flagships included Bomber Blonde Ale, Sodbuster Pale Ale, River Market Red and Flying Crow Porter. Eight-Ball Cream Stout earned a silver medal in the sweet stout category at the 1998 Great American Beer Festival. The brewhouse consisted of a 25-barrel brew kettle, a 548-gallon mash tun and a 565-gallon uni-tank. Stationed in the loft above the bar, the brewery's three 550-gallon copper open fermenters were used for primary fermentation. The brewery also had a closed, conical fermenter; five secondary fermenters in the basement icehouse; and five serving tanks. The brewery distributed kegs between 1995 and 1997 and also sold "Party Pigs" and glass growlers for take-home consumption. Annual production averaged 1,000 barrels with between 1,400 and 1,600 barrels at its busiest point.

Palmer hired Angelo Gangai, former general manager of Boulder Brewery in Boulder, Colorado, and Rock Bottom Brewery in Denver, Colorado, to run the restaurant side of the business. Gangai is now a general manager at KC Hopps.

River Market Brewing expanded twice, taking over the Comedy City space next door and later opening a second floor for a 150-seat event space.

"River Market Brewing was the 104th registered brewpub in the U.S. when we began operations in March 1995," Palmer said. "When I left in 2002, there were well over 2,000."

Palmer sold his majority owner interest in March 2002 to Dave Pecha, who operated the brewery until it closed in February 2009. River Market Brewing had been for sale for several months prior to closing but failed to attract a buyer for the business.

1995: Pony Express Brewing Company

This brewery (311 North Burch, Olathe, Kansas) bolted out of the gate with a promising start, faltered, regained its footing and ultimately closed. Joe Effertz, a former liquor store owner and wheat farmer, and business partner Ed Nelson founded the company in 1995. The brewery's name and image drew on the history of the Pony Express, a cross-country mail delivery service by horseback that originated in St. Joseph, Missouri, and reached points as far west as Sacramento, California, using relay stations.

Head brewer Stacey Payne led brewing operations at Pony Express Brewing from 1997 to 2004 under the original ownership and a second group. He left the company to become brewmaster at Amerisports Brew Pub at the Ameristar Casino, where he still works.

Payne also served as president of Pony Express Brewing from the summer of 2001 to April 2002 during a difficult stage for the company. Annual sales at Pony Express reached $640,000 at one point but dropped off to $480,000 by 2001. According to Payne, sales declined in part due to a change in ownership when Dallas-based Glazer's Distributors acquired Premiere Distribution. Pony Express became a low priority for the new sales force. Terrorist acts on U.S. soil on September 11, 2001, took an economic toll as well. "People stopped going out," Payne said. "Our draft account numbers dropped."

Combined with low sales and a depressed economy, Pony Express also faced competition from Boulevard Brewing Company and regional and national brands competing for taps and retail shelf space. The brewery closed in April 2002 with six employees at the time. Pony Express put its recipes, trademarks and equipment on the market.

Pony Express beers included Rattlesnake Pale Ale and Unfiltered Wheat, which both earned a silver medal at the World Beer Championship; Honey Blonde Ale; Great American Beer Fest (GABF) silver medalist Tornado Ale; and bronze medalist Nut Brown Ale. Pony Express products were sold in Kansas, Missouri, Iowa, Oklahoma and Nebraska. Seasonal beers included Holiday Ale, Red Sky Rye, Hailstorm Hefeweizen and Blizzard Ale.

Over its lifetime, Pony Express contract brewed and bottled for numerous clients, including Breckenridge Brewery's Avalanche and Hefe Proper, both packaged in sixteen-ounce plastic bottles, and Bricktown Brewery in Oklahoma City, Oklahoma. Payne brewed Royal Raspberry Wheat, Saxy Golden Ale and Possum Trot Brown for 75th Street Brewery. KC Hopps was an initial investor in Pony Express. Flying Monkey Brewing, owned by

founder Robert Eilert, closed in 1999 after a severe flood the prior year. It attempted to reopen, but poor sales led to Eilert selling the brewery to Pony Express, which brewed several Flying Monkey brands.

The annual capacity of Pony Express by 2002 reached between ten and fifteen thousand barrels. By comparison, Boulevard Brewing Company, the largest brewery in Kansas City, brewed sixty-three thousand barrels that same year. According to Payne, the highest production Pony Express ever achieved in a year was around five thousand barrels.

The brewery saw new life in March 2003. Great Plains Holding Company doing business as Pony Express Brewing, and funded by agricultural cooperative TransCon AG, assumed ownership of the business. A member of the co-op, who was an original investor in Pony Express, brought the business opportunity to the agricultural group.

Payne resumed duties as head brewer. He supervised packaging, handled laboratory work and filtration and performed other tasks. Michael Cook served as executive director at Pony Express. High Life Sales Company, now known as Central States Beverage Company, distributed Pony Express's line of beers.

The co-op had been looking for ways to use its crops in value-added products. Locally grown soy was used in Pony Express Gold, a new beer brand introduced in 2003. Pony Express attempted to develop an overseas market for Pony Express Gold under the new leadership. Cook, having developed relationships in China through other agribusiness ventures, began seeking opportunities to distribute beer in Chinese hotels and restaurants. Payne traveled to China for a week to meet counterparts there who inspected the shipping container of beer. Loose filtering of Gold resulted in residual amounts of yeast in the bottle.

"The regulatory board in China didn't know much about yeast and fermentation," said Payne, who tried to explain the purpose of its presence in the bottles. "I think they began to understand but didn't accept the beer. It wasn't their place to change the law."

Unknown to Payne, original Pony Express co-founder Effertz was also a silent partner in the new ownership group. Effertz angled to complete a deal to produce an alcoholic beverage in large volumes. Given the volume desired and the capacity and age of brewery equipment, Payne advised that "the numbers didn't add up" from a financial standpoint. Around this time, Ameristar Casino called and recruited Payne for its new brewpub concept.

Payne's assistant brewers remained on staff for a month before departing. Brewing technical advisor Joe Pickett was brought in as a consultant to help

install packaging equipment. A former employee of PepsiCo was allegedly hired to run the brewery but didn't have much relevant experience.

Junghoon Yoon, a graduate of the University of California–Davis brewing program, worked at Pony Express from April 2004 to November 2005, during Pickett's contract. Pickett traveled between his home in Las Vegas and Kansas during the consultancy.

"Joe used to come to Kansas once a month or every two months for a week to train me, modify the system and purchase brewing equipment," said Yoon.

Within four months, Yoon was able to brew Pony Express's beer independently. Pickett continued to share advice and know-how during his contract.

In December 2005, Yoon returned to Korea and worked for several breweries there before he transferred to Platinum Craft Brewing Company in 2010 as brewmaster and chief operating officer. Yoon and his boss later moved to Yantai, China, where they installed the first craft production brewery. He developed American-style craft beers for the Korean and Chinese market. Platinum's beers have won fourteen medals and have the biggest market share in Korea. The brewery has the capacity to produce 2.4 million liters (nearly twenty-five thousand barrels) of American-style craft beer each year.

"I am still proud that I learned practical brewing knowledge from Joe at that time, and I was inspired by his American brewing spirit," Yoon said. "I believe that I couldn't be a brewmaster, a member of the judging panel of many international beer competitions and COO of Platinum Brewing Company if I wasn't in Kansas."

Pony Express Brewery closed again after 2005. Robert Eilert reacquired rights to his Flying Monkey beer brands and also secured rights to Pony Express Gold. He continued to brew those brands at the Olathe brewery until 2009, when he decided to use a contract brewer. Payne suggested that Eilert contact Weston Brewing Company. Subsequently, Weston Brewing acquired Flying Monkey's brand and continues to brew its beers today. By 2009, the Pony Express brand had finally ended its run.

1995: Dave's Brewpub

Founded on June 1, 1995, by David Cattle, Dave's Brewpub (10635 Floyd, Overland Park, Kansas) was a small venue established in a strip mall with modest decor. According to a 1999 online review by blogger Tom Ciccateri,

Dave's had a small half-barrel brew system in the space along with parlor games for amusement and pizza for dining.

The beers included Dave's Wheat; Nitro Pale Ale; Fred's Habeñero, described as "a clear dark gold color with a pungent, non-chile aroma"; a Holiday Ale laced with notes of cinnamon and nutmeg; a "thin-bodied" Irish stout; Dave's Doppel Bock; Dave's Dark (a German-style dunkel); Cattle Drive IPA; and Mother Earth Stout. A Coconut Curry Hefeweizen had an initial "spicy" aroma and flavor that mellowed to a light coconut flavor. Standard price at the time was $1.75 per eight-ounce glass.

A 1999 application for renewal of a Kansas drinking establishment license listed Mike Watson as the manager. No information is available about when the brewpub closed. The retail strip mall space subsequently became home to Stanford & Sons Comedy Club and also an event space.

1995: OVERLAND BREWING COMPANY, SPORTS PAGE BREWERY

Overland Brewing Company (9083 Metcalf Avenue) operated from June 16, 1995, until sometime in 1998. Not much is known about this brewpub and why it closed.

Mug Club membership cost twenty-five dollars to join. Every Wednesday during happy hour, it cost one dollar to fill the mug, according to former club member Robert Adams of social group Beer Tasting Kansas City.

Nabil Saleh was listed as manager on Overland's applications for renewal of drinking establishment licenses in 1997 and 1998 for the following operating year. Saleh was also a partner in the company.

The applications listed Overland Brewing Company doing business as Sports Page Brewery. No other evidence suggested this brewery was legally connected to Sports Page Brewery (3512 Clinton Parkway) in Lawrence, Kansas. That Kansas brewery was in the process of being developed in 1996 by Allen Salah, who also owned Bayou State Restaurant and Brewery.

Nabil Saleh and Allen Salah were not related and apparently had no direct business dealings with each other. When Salah's brewery project and assets were in bankruptcy, Nabil Saleh offered to buy the Lawrence brewery location for $300,000. This deal didn't come to fruition. See the 1996 entry for Bayou State for more details about its history and Sports Page Brewery in Lawrence.

1995: High Noon Saloon and Brewery, Grinders High Noon

High Noon Saloon and Brewery (206 Choctaw Street, Leavenworth, Kansas) was established in the Great Western Building, an 1870s-era cast-iron stove factory located near the historic Oregon and Santa Fe Trails.

Brewer and owner R.D. Johnson and his wife, Anna, established High Noon's brewery in 1995 and bought the restaurant side of the business three years later from a prior owner. Located near the U.S. Army's Command & General Staff College in Fort Leavenworth, High Noon drew enlisted men and women, business travelers and locals.

Johnson, a retired army officer, first gained a taste for German beer while stationed in Germany. His lifelong love of beer motivated him to operate a brewery and stay in the business for two decades.

Johnson's brewhouse equipment included a five-barrel stainless steel mash tun, copper boil kettle, two copper fermenters, a stainless steel uni-tank fermenter and a hot liquor tank in the tight space. Johnson hired electrical and refrigeration tradesmen in the mid-'90s who had never worked on a brewery installation. Lacking guidelines or clear instructions back then, Johnson found that the project took far more time and money than anticipated. Five Premiere stainless steel tanks from the Czech Republic were later added to the rear of the building to increase serving capacity at the bar. The brewery produced about five hundred barrels per year.

Brewmaster John Dean, now the multiple award-winning head brewer at Blind Tiger Brewery in Topeka, Kansas, trained Ed Baldwin, who joined High Noon in 1998, in the craft of brewing. Other former brewers included Rich Barbudo, Ty McGuire and Will Johnson.

The beer's brand imagery featured traditional Wild West themes, iconic western figures and curvy women in western wear. High Noon's beers included Annie's Amber Ale, Tonganoxie Honey Wheat, Oregon Trail Raspberry Wheat and Rough Rider Pale Ale. Stampede Stout, a robust coffee stout, was a 2011 and 2013 silver medalist in the World Beer Championships. Raspberry Wheat secured a gold medal in the Fruit Beer category in the 1998 Great American Beer Festival in Denver.

Circa 2009–10, Johnson purchased a canning line and sizeable can inventory. He launched Annie's Amber Ale in cans, followed by other brands. High Noon faced distribution challenges to gain space on store shelves. The brewery did sell growlers on site and kegs through Premiere Distributing to regional bars and restaurants.

Right: High Noon Saloon and Brewery owner R.D. Johnson. The brewery was renamed Grinders High Noon in 2015 under new ownership. *Photograph by Pete Dulin.*

Below: High Noon's tap handles, cans and branding featured curvy women in revealing western wear. *Photograph by Pete Dulin.*

The Johnsons retired, closed the business in April 2015 and sold it to Jeff Rumaner, owner of several Grinders pizza restaurants in Greater Kansas City. Rumaner remodeled and reopened the restaurant-brewery in June 2015 as Grinders High Noon.

1996: Flying Monkey Brewing Company

Flying Monkey Brewing Company founder Robert Eilert displays a tattoo of the brewery's signature logo on his arm. *Photograph by Pete Dulin.*

Flying Monkey founder Robert Eilert began homebrewing in the late '80s. A career change prompted Eilert's entry into professional brewing. He quit a career in finance in 1992, moved from Kansas City to Denver and secured a job working on the bottle line at Breckenridge Brewery. He was promoted to controller and then director of operations.

Eilert developed the Flying Monkey concept and co-founded the brewery with Drew Jones in 1996 in Kansas City. Flying Monkey's beers included Amber Ale, Wheat and Four Finger Stout.

His Merriam, Kansas brewery (5151 Merriam Drive) closed in 1999 after suffering damage from a 1998 flood. Eilert sold his business assets and brand to Pony Express Brewing. Pony Express brewed Flying Monkey's beers until that company closed in 2002. Pony Express reopened under new ownership in 2003, later sold its interest in Flying Monkey and equipment back to Eilert and closed sometime after 2005. Flying Monkey operated until 2009 out of the former Pony Express brewery in Olathe. When Eilert decided to contract brew instead of operating as a production brewer, he contacted Weston Brewing Company. This brewery in Weston, Missouri, bought the Flying Monkey brand and continues to brew Flying Monkey beers today.

1996: BAYOU STATE RESTAURANT AND BREWERY, SPORTS PAGE BREWERY

Brauereihaus Inc., the parent company of brewery developer Allen Salah, owned Bayou State Restaurant and Brewery (5005 West 117th Street, Leawood, Kansas). Bayou State opened in a ten-thousand-square-foot space in July 1996 in Town Center Plaza. Bayou State Brewery had a Louisiana jazz theme with the slogan "Fear No Beer" and served New Orleans and American cuisine. Business fell off sharply after its initial opening due to "poor publicity," according to the restaurant's general manager, J.R. Sutton, in news reports.

Meanwhile, Salah had plans to develop Sports Page Brewery (3512 Clinton Parkway) in Lawrence, Kansas. However, Salah's business dealings caught up with him. As reported in the *Lawrence Journal-World* on January 9, 1996, Salah left the United States for Bahrain in the Middle East after burning documents in his home fireplace. He left a long trail of debt. Salah's creditors included three banks, Town Center Plaza and an interior designer. They sought repayment of nearly $1 million debt left behind by Salah's parent company. In 1996, developers of Town Center Plaza sought nearly $120,000 in back rent and taxes in Johnson County District Court but later settled under undisclosed terms.

A follow-up story dated February 12, 1997, in the *Journal-World* reported, "In mid-December, a gas line in the [Sports Page] building was sabotaged, allowing the brewery to fill up with natural gas." Investigators discovered the gas leak, which failed to ignite because electricity was not connected in the building. Salah was never charged with arson. Further, investigators discovered that Salah had spent time in prison after pleading guilty to three counts of bank fraud and making false statements to the United States.

A U.S. bankruptcy judge appointed a trustee to take control of Brauereihaus's assets under bankruptcy. On January 19, 1997, the *Kansas City Business Journal* reported, "PB&J Restaurants Inc. has been appointed interim manager of the Bayou State Restaurant and Brewery in Leawood following the disappearance of the restaurant's owner." Bayou State Brewery continued to operate while Salah's assets were under review in bankruptcy court. Also, the Alcohol Beverage Control Department in Topeka reviewed Bayou State's license to determine whether the brewery would retain its license. Bayou State Restaurant and Brewery closed by July 1997, approximately one year after opening.

At one point, Nabil Saleh (no relation) of Overland Brewing Company proposed a buyout of most of the fixtures in the beleaguered Sports Page

Brewery. Assets included booths, televisions, cash registers and some kitchen equipment. It doesn't appear that sale of Sports Page Brewery's assets to Saleh manifested.

Allen Salah surfaced in Kansas once again. The *Journal-World* reported on October 2, 2004, that Salah, accused of scamming investors in the mid-1990s, was brought back to Douglas County to face criminal charges. He was arrested on a traffic stop in Illinois earlier that summer and returned to Kansas. He was also wanted in Texas. Salah made his $15,000 bail bond and skipped out of Lawrence a second time.

The property at 3512 Clinton Parkway in Lawrence, once intended to be Sports Page Brewery, finally opened as 75th Street Brewery in April 2004 with Matt Llewellyn as managing partner. The brewpub later changed its name in December 2006 to 23rd Street Brewery.

1997: Gravity Brewing Company

Homebrewers and business-minded entrepreneurs entered the market in the '90s with plans to capitalize on the growing popularity of microbrewed beers. This race to enter the market resulted in poor-quality beer from some profit-minded, quick-to-market brewpubs and breweries. Deceptive marketing and "brew on premises" concepts also soured consumers on microbrewing. Breweries with adequate funding that offered high-quality beer, built integrity and grew an audience one pint at a time survived the era. Other operations quickly folded.

Philadelphia beer blogger Jack Curtain logged the origins of Gravity Brewing Company. Three former University of Pennsylvania students introduced America-U-Brew, a do-it-yourself Brew On Premises concept that sprang up around the United States, to Philadelphia in early 1995. These facilities provided the equipment and materials for consumers to brew their own beer on site using established recipes and practices. Philadelphia was the company's fifth U.S. location, with two more to follow in the city. Mike Morrissey, one of the three partners, decided that the group should create and market its own microbrew brand, Gravity Pale Ale. Brewing was done with extracts, a shortcut, but most consumers at the time weren't savvy to how beer was made.

One of the Philadelphia locations closed and relocated in 1997 to Kansas City (4027 Mill Street) in Westport's Mill Street shopping strip. As Gravity Brewing Company, the U-brew operation combined "personal brewing, contract brewing, and the manufacture of Gravity Pale Ale for resale." The plan was to acquire or partner with other brew-on-premises operations, build Gravity microbreweries in multiple markets and create a national brand yet brew small batches in local markets. The plan flopped. Kansas City's branch of Gravity Brewing quickly closed. Better-quality beer and more variety were available on tap and in bottles from actual breweries.

A six-pack of Gravity Pale Ale from U-brew operation Gravity Brewing Company. *Courtesy of John Bryan.*

1997: McCoy's Public House

McCoy's Public House (4057 Pennsylvania Avenue, mccoyskc.com) succeeded Westport Brewing Company when that brewpub closed after a financial scandal. Other businesses such as the nightclub Harris House occupied the space briefly but didn't last long. The property was vacant for a long time given its prime location at the epicenter of Westport.

Owners James Westphal, Mark Kelpe and Marty Collins developed the concept for McCoy's Public House and launched the brewpub.

"Free State Brewery opened during my junior year at the University of Kansas," said Westphal. "I immediately fell in love with craft beer and promised myself that someday I would own a brewpub."

Restaurant group KC Hopps was also an original investor and part of the management group. The brewpub was named after Westport founder John Calvin McCoy, who developed the area from a trading post into a town before it merged with Kansas City.

Introducing a brewpub to Westport was a bold decision. Inexpensive macro beer reigned on tap at area bars. Pale ale, stout and other styles were unfamiliar to most college-age students, post-college graduates and

other drinkers accustomed to light lagers. Boulevard Brewing Company, 75th Street Brewing Company and River Market Brewing Company first introduced locally microbrewed beer to a new generation of Kansas City's beer drinkers. McCoy's demonstrated there was room for a brewery in the city's premier entertainment district.

Head brewer Keith Thompson, formerly with 75th Street Brewery, installed McCoy's brewhouse and oversaw brewery operations through 2014. Neil Witte, now with Boulevard Brewing Company, moved to Kansas City in April 1997 and began his first brewing job as Thompson's assistant. Current head brewer Morgan Fetters was hired in June 2010 as a server and trained as an assistant brewer in 2012 under Thompson before taking the lead role. Emily Yeager,

Head brewer Keith Thompson helped to launch McCoy's Public House in 1997 and managed brewhouse operations for nearly two decades. He co-founded Brewery Emperial in 2016. *Photograph by Pete Dulin.*

a homebrewer and University of Missouri–Kansas City graduate with a degree in biochemistry, was hired in mid-June 2014 as a part-time brewer.

The nineteen-year-old brewhouse consists of a ten-barrel system, an English-style mash tun and lauter, hot liquor tank, three ten-barrel fermenters and one twenty-barrel fermenter on view within the brewhouse. An additional three twenty-barrel fermenters are stored in a 144-square-foot "closet" located along the length of the building that connects McCoy's and sister bar The Foundry located next door. The main brewhouse is a mere 450 square feet, and the icehouse is 420 square feet.

The bar features twelve taps that carry eleven house beer styles and a cider. A separate dedicated tap is tied to an English-style cask system installed behind the bar. English-style ales are drawn from the cask in traditional manner at forty-eight degrees, or below room temperature. Because McCoy's brewhouse has a fixed brewing capacity, the brewpub does not distribute its beers to outside businesses other than its sister restaurants.

Flagship beers include Hogpound Brown Ale, Newcom's IPA and rotating styles of stout, wheat and lager. Raspberry Wheat, Munich Lager, Good

Farmhouse Ale and Oatmeal Stout are a few of the nearly seventy styles that McCoy's has brewed since inception. That variety is a marked difference between modern craft breweries and pre-Prohibition operations that focused on volume.

McCoy's popular warm-weather seasonal Ginger Shandy is made by adding sugar and fresh-pressed juice from fresh ginger and lemons to the beer post-production. Shandy is a traditional light beverage that blends beer with juice or a soft drink like ginger ale.

"Originally, Keith used ginger extract, but he switched to fresh juice," said Randyl Danner, beer and beverage director at McCoy's. "Ginger Shandy was Keith's answer to Zima when it came out and people were ordering it instead of beer."

While Zima, a popular fruity alcoholic beverage from the 1990s and early 2000s, is long gone, Thompson's Ginger Shandy endures as a refreshing example of a shandy. His approach to brewing many different styles of session beers was instrumental to McCoy's longevity.

"Keith excelled at brewing English-style brown ales, IPA and fantastic lagers," Danner said. Lager, a traditional German style that requires longer time to ferment and cellar, is more difficult to master and produce in scale with quality results compared to other styles. Danner added, "Keith passed his knowledge of lager and other styles to Morgan and Emily. They understand the time it takes and the complexity of lager."

McCoy's earned seven medals during Thompson's era, bringing home silver and bronze awards for its IPA, Ginger Shandy, Wee Willy Scotch Ale and Pilsner. Fetters and Yeager also brought a gold medal home for McCoy's Ursa Minor, an imperial brown ale, from the 2015 Great American Beer Festival in the Strong Beer category.

Fetters said, "That beer was my first all-grain recipe from my homebrewing days that we blew up and imperialized."

Fetters, Danner and Yeager have worked closely to further refine McCoy's brewing program. They have "critical conversations" about beer, taste batches and new recipes and discuss how to improve styles and overall quality. McCoy's approach to brewing allows for slight intentional variation between batches, according to Fetters.

"With our core group of devout IPA drinkers, they know it will change," Fetters said, "if we have tweaked the recipe from the original."

For example, Thompson's version of Newcom's IPA was an earthy, English-style compared to the current American style that leans toward citrus and pine aromas and flavors preferred by contemporary beer drinkers.

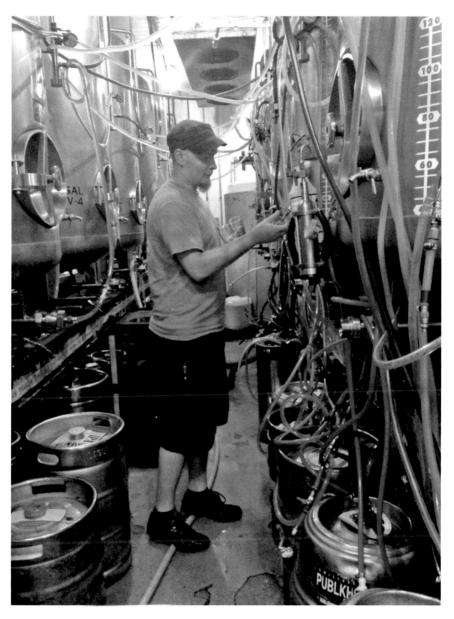

McCoy's Public House head brewer Morgan Fetters in the brewhouse, circa 2014. *Photograph by Pete Dulin.*

These micro-adjustments in brewing contrast with mass-produced lagers from pre- and post-Prohibition breweries, where such refinements at scale weren't commonplace.

Not content to rest on its reputation or prime location, McCoy's Public House has held annual beer festivals, beer dinners and other events to stimulate conversation about and demand for locally brewed beer. The brewery has also steadily developed its next generation of brewers to lead its brewing program well into the twenty-first century.

1999: Power Plant Restaurant and Brewery

Steve Palmer, owner of River Market Brewing Company, opened his second business (2 Main Street, Parkville) in December 1999. Fortunately, fears of a worldwide Y2K meltdown of computerized systems as a result of a coding problem did not manifest. Built in 1918, the building that housed the restaurant and brewery was formerly Parkville's steam-generating, coal-fired power plant with four large boilers. Extensive renovation and expansion was needed to convert the space into a brewpub.

The building's landlords removed three boilers and added an interior "mezzanine" that would become the brewery's main dining room. A two-story attached building was added to the rear of the main structure. The brewhouse equipment was acquired from Bootleggers Steakhouse and Brewery in Bakersfield, California. An icehouse was installed along with conditioning vessels, updated plumbing, kitchen, ventilation hood, a brewery boiler atop the building and an outdoor stairway for access to outdoor deck seating. The plant retained its iconic smokestack until 2008, when it was removed due to expensive repairs needed.

Flagship beers included Colonel Park's Pale Ale, Southbound Nut Brown, Steamboat Stout and Walnut Creek Wheat, plus a seasonal beer. Brian Reinecke, head brewer at River Market Brewing, ran the brewhouse at Power Plant until brewer Gordon Gerski took over brewing duties. Palmer estimated brewery production at five hundred barrels per year or fewer with no keg distribution.

A major train derailment on April 14, 2000, dumped "a sea of coal in front of Power Plant and covered Main Street and the rail crossing," according to Palmer. Two nearby businesses were wiped out. Only a piece of concrete at the brewery was damaged.

The brewery—still in its honeymoon period after opening less than four months earlier—closed for six weeks during cleanup of the wreck. The brewery lost half of its wait staff and kitchen staff and had to rehire. It also had to market the brewery heavily to regain business.

Angelo Gangai, general manager at River Market Brewing, assumed similar responsibilities at Power Plant throughout its lifetime. Along with majority owners Palmer and Gangai, Phil Johannes, who helped to raise initial capital, shared a minority ownership and was the largest equity shareholder of the brewery. Palmer primarily ran River Market Brewing and oversaw financial accounts and payroll for both breweries. When Palmer decided to sell his stake in both breweries, Johannes became the primary owner of Power Plant Brewery.

Proximity to the railroad tracks in downtown Parkville was part of the brewery and restaurant's appeal. "It certainly rumbled the place as the freight and coal trains passed by," Palmer recalled. "We had a band there once that would stop whatever cover song they were playing at the time when a train rambled by and instantly broke into their rendition of Johnny Cash's 'Folsom Prison Blues.'"

Power Plant Restaurant and Brewery closed in October 2008.

Twenty-first-Century Breweries

2002: Amerisports Brew Pub

Amerisports Brew Pub, a massive 11,588-square-foot sports-themed brewpub that opened in September 2003 within the Ameristar Kansas City casino (3200 North Ameristar Drive), replaced the Hofbrau Haus, a German-style biergarten. Award-winning brewmaster Stacey Payne succeeded brewer Michael Snyder at Amerisports. Payne helped to launch the brewery and created beers that differed from Amerisports concepts at Ameristar Council Bluffs and Ameristar St. Charles.

Payne graduated from the American Brewer's Guild at University of California–Davis. Afterward, he completed an internship in 1997 at Boulevard Brewing Company. Payne was the head brewer at Pony Express Brewing from 1997 to 2004 and briefly served as its president before coming to Amerisports.

Amerisports' beer roster includes best-selling Court Light, an American wheat lager that was originally a helles; Knock Out Blond Pilsner; Face-Off Pale Ale; Red Zone Lager; and Hard Ball Dark, a German-style dark lager. Payne also brews small-batch, unfiltered brews that rotate on the taps, including an IPA, Saison and Winter Warmer. The Winter Warmer and Face-Off Pale Ale are based on Blizzard Ale and Rattlesnake Pale Ale, respectively, which Payne once brewed at Pony Express Brewing Company.

When Payne started, casino customers at the brewpub ordered one beer brewed in-house for every two to three bottles of macro beer. Now, that

ratio is reversed as the brewer and servers have educated customers about the differences in flavor and value. A twenty-three-ounce beer costs a value-priced $4.50 per glass. The brewery also sells beer in growlers.

Shiny copper cladding covers all the stainless steel brewhouse equipment. Surrounded by glass windows, the fifty-barrel brewhouse has seven sixty-barrel fermentation vessels, five sixty-barrel serving vessels and a pair of yeast propagators that are also used for small-batch production of limited release and seasonal beers. Annual production averages one thousand barrels.

Payne said, "My capacity is ten thousand barrels if I were to do all ales and around five thousand barrels if I were to do all lagers because of the extra fermentation and conditioning time for lagers."

Payne hopes to expand capacity and increase the serving vessels to a dozen on site so that the brewpub can offer a wider selection of beer styles.

2009: Doodle Brewing Company

Brewer Nick Vaughn started Doodle Brewing Company in Liberty, Missouri. Vaughn earned a degree in chemical engineering from the University of Missouri. He began brewing after college at Harpoon Brewery in Boston in 2003, moved back to Missouri and worked at 75th Street Brewery in 2006. He also worked at SCD Probiotics, a firm that produces and distributes all-natural, liquid probiotics, and ran its probiotics brewery while developing Doodle Brewing.

The brewery sold its first case of Doodle Dubbel in February 2011 to Grand Slam Liquor in downtown Kansas City. Vaughn depleted his funding before he could release additional beers such as Sage Belgian Imperial Porter and Vanilla Stout.

Vaughn was hired as brewmaster at Martin City Brewing Company and helped to install and launch the brewery in February 2014.

2011: Wilderness Brewing Company, Mankind Brewing Company

Hopeful entrepreneurs began to use Kickstarter and other online crowd-sourced funding options to raise capital and launch brewery startups with

varying success. Each crowd-sourced fundraising effort outlined the project scope, goals and inherent risks.

Nate Watson and Mike Reinhardt launched a Kickstarter campaign for Wilderness Brewing Company on May 31, 2011, and by August 4, 2011, had raised $41,100 with 372 backers, surpassing the $40,000 goal. (Full disclosure: The author contributed a minor sum to the campaign.) The campaign received press from local media, beer bloggers and social media.

Between August 2011 and August 2014, Wilderness Brewing issued multiple updates on its "progress." Essentially, Wilderness "continued to purchase and construct various aspects of our equipment" and was "still looking for a location that works well from a code, legal, and budgetary standpoint."

The last Kickstarter post in 2014 offered a lengthy apology, assurances and a rambling explanation of how Reinhard and his wife, both Southern California transplants, were building a house by hand as part of settling down in Missouri. A Facebook post dated September 10, 2014, noted that they commissioned the manufacture of a custom boil kettle. A photograph posted of the kettle revealed its small size. Further, they stated that an "ideal location may have been found in Holden, Missouri. We are waiting on the legal information to be sorted through by next week." No other communication has been issued to supporters since then.

Wilderness Brewing became a cautionary tale for would-be backers of online fundraising campaigns. Backers received infrequent updates with vague information after providing a large sum of capital. No brewery or beer appears forthcoming for skeptical supporters and the Kansas City market from Watson and Reinhardt.

Brewer Micah Weichert launched a Kickstarter project on December 28, 2012, to raise $30,000 for the launch of Mankind Brewing. By February 11, 2013, the project only had $20,658 pledged and did not meet its goal. No monies were collected, and the brewery never launched.

Weichert has ample brewing experience and a well-regarded reputation. He was head brewer at 75th Street Brewery and Waimea Brewing Company in Kauai, Hawaii. He helped launch a production facility for the Brugge Brasserie in Indianapolis, Indiana, and also brewed at Pony Express Brewing Company and 23rd Street Brewery. Weichert also worked as a brewer at Gordon Biersch Brewing Company in Kansas City. Weichert served as a consultant in 2016 at Stockyards Brewing Company prior to its launch and became its full-time brewer when Stockyards opened.

These examples provided a learning curve for both potential supporters and entrepreneurs seeking funds to open a brewery. Several breweries, funded through various means that typically involved personal funds, investors and bank loans, have opened in Kansas City since 2011 and continue to grow.

2011: Martin City Brewing Company

Martin City Brewing Company (500 East 135th Street, martincitybrewingcompany.com) is named after the former town platted in 1887 by E.L. Martin and John H. Lipscomb. Originally called Tilden, the town at 135th and Holmes was later named after Kentucky-born Edward L. Martin, who came to Missouri in 1868 at the age of twenty-six. He organized the Kansas City Distilling Company and E.L. Martin & Company wholesale liquor. Martin was mayor of Kansas City in 1873 and served on the Board of Education from 1875 to 1896. Martin City was annexed into the Kansas City, Missouri city limits in 1963 along with much of south Jackson County.

Nearly fifty years later, Martin City Brewing was co-founded by Matt Moore, a landscaper, and Chancie Adams, a project manager for a pharmaceutical development company. The two friends were stymied by the lack of venues that served both quality craft beer on tap and upscale food in south Kansas City. Moore and Adams batted around ideas for various food or beverage-related businesses, including a coffee shop and breakfast diner, before they settled on opening a brewery.

"If I wanted good food and beer at the time, I had to go to Waldo or downtown," Moore said. "Opening a brewery in Martin City made perfect sense to me, but I had one thousand people say it was the dumbest idea in the world."

In retrospect, the idea proved prudent as the business quickly gained a following. The business partners first opened a pub in June 2011 that served craft beer on tap and refined pub food. The pub wasn't large enough for a large-scale production brewery, but it generated cash flow for the next phase of growth.

In February 2014, Moore and Adams opened a brewery, wood-fired pizza restaurant and taproom next door to the pub. Prior to opening, Jeremy Danner of Boulevard Brewing referred fellow brewer Nick Vaughn to Moore, who had posted an ad on an online brewers' forum. Moore and Adams met Vaughn and hired him as their head brewer. Vaughn, educated

as a chemical engineer, had brewed at Harpoon Brewery in Boston and 75th Street Brewery in Waldo and launched short-lived Doodle Brewing. Vaughn was instrumental in the construction, installation and ongoing production of Martin City Brewery's two-vessel, fifteen-barrel brewhouse.

Additional equipment at the brewhouse now includes seven serving tanks, two 30-barrel fermenters and 100 whiskey and brandy barrels for aging. In 2015, they added a 30-barrel foeder, a large wooden vat used to age sour beers. Annual production capacity is 3,000 barrels. In 2015, they produced 1,300 barrels in volume.

Vaughn eschews the strict boundaries of traditional beer styles and instead develops Belgian-centric beers with striking flavor and aroma. Martin City's portfolio of beers has quickly established itself as one of the more distinctive rosters that extends beyond basic wheat, stout, pale ale and IPA. Core beers include Abbey Belgian Ale, Belgian Blonde, Belgian IPA, City Saison and Hardway IPA. Seasonal and barrel-aged versions of its beers are rotated on tap.

The brewery's barrel-aging program features wild and sour ales as well as beers aged in bourbon, brandy, Pinot and Chardonnay barrels. Specialty beers include Brandy Barrel Aged Tripel and Big Boy Bourbon Barrel Aged Imperial Stout. In 2015, the brewery began bottling several of its high-end beers in 750-milliliter bottles, including Coming Undone, a complex Flanders red-style beer; Dream Quest, a golden ale fermented and aged in Chardonnay barrels with Brett yeast; Colour Out of Space, a Belgian black ale fermented and aged in barrels with Brett yeast; and Quid Feci, a saison fermented in Pinot Noir barrels with cherries and Brett. Martin City Brewing also collaborated with craft beer taproom Bier Station to create and release limited-edition Station to Station Berliner Weisse.

The brewery signed a distribution deal in November 2014 with Central States Beverage Company. Vaughn and assistant brewer Grant Bergmann created the initial offering from Martin City Brewing that included Belgian Blonde, Belgian Abbey, English Bitter, Saison No. 3, a black IPA and a coffee stout featuring Benetti's coffee. Several of Martin City's beers are available on tap at more than fifty Greater Kansas City metro and Johnson County bars and restaurants.

In 2015, Martin City Brewing Company (MCBCo.) filed a trademark license with the United States Patent & Trademark Office (USPTO) for its product under the name "Hard Way IPA." Martin City Brewing filed for this trademark as an "actual use of product" one day ahead of Anheuser-Busch's

(A-B) "intent to use" trademark application. The USPTO suspended the A-B application based on Martin City Brewing's previous filing.

Before 2015 concluded, the brewery's owners had opened yet another business, The Martin, an event space located at 13440 Holmes in the former home of Martin City Melodrama & Vaudeville Company.

In mid-2016, Martin City Brewing installed a canning line and planned to can and distribute Hardway IPA, City Saison, Belgian Blond and Abbey Belgian Ale as its four core beers, plus a rotation of seasonal beers.

2012: GREEN ROOM BURGERS AND BEER

Michael Ptacek opened Green Room Burgers and Beer (4010 Pennsylvania Avenue, Suite D, greenroomkc.com) in February 2012, but the Westport restaurant didn't establish its one-barrel nanobrewery for another eleven months. The venue is next to the ground-floor theater of neighboring Westport Coffeehouse, where the KC Improv Company performs.

Naysayers told Ptacek, a homebrewer for six years, that "opening a brewery was impossible (without a million dollars)." However, his wife, Cindy, provided a supportive nudge. Rather than spend an inordinate amount of time homebrewing, he devoted effort toward developing a business plan. Ptacek credited his father, Tom, as a key supporter and critic early on as the business opened.

Former head brewer Chris Flenker left in 2015 to become head brewer at Iowa's Toppling Goliath Brewing. Ptacek, Kalim Kazmi and Noah Kent now share brewing duties.

Green Room's balanced English pub–style beers are served on the warmer side with less conditioning. The brewhouse may be "toured" in a minute by walking past a window that offers a view of a small brew room. The brewery serves several beers made in-house and guest craft beers on tap with one selection served from its cask. Papa Louie's is a dark mild cask ale named after Ptacek's paternal grandfather. Old Country Promise, a French saison, is another favorite on rotation. Bird Lives, a double IPA brewed and served every August 29, is a tribute to Kansas City jazz legend Charlie "Bird" Parker. The brewery uses a rye whiskey barrel from Union Horse Distillery (formerly Dark Horse Distillery) to age specific beers.

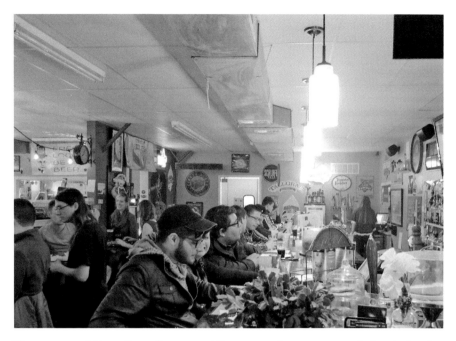

The taproom of Green Room Burgers and Beer, a nano-brewery, was packed on its fourth anniversary in February 2016. *Photograph by Pete Dulin.*

2013: The Big Rip Brewing Company

Homebrewers Kipp Feldt and Josh Collins founded the Big Rip Brewing Company (216 East Ninth Avenue, North Kansas City, bigripbrewing.com) in May 2013. The brewery and taproom is located minutes from downtown Kansas City. The Big Rip was the first of several locally owned breweries to open in the Northland that year, soon followed by Cinder Block Brewery and Rock & Run Brewery and Pub.

The Big Rip's name is inspired by a scientific theory that departs from the Big Bang explanation for the origin of the universe. The Big Rip theory proposes that the universe is expanding and in time will defy gravity and disband galaxies and solar systems, and the universe will ultimately end. That foreboding prospect helps to explain the slogan on the brewery's T-shirts: "Lighten Up, Dark Matter. Relax, Have a Beer."

Collins and Feldt first met while working at Tekniq Data, an information technology firm. They enjoyed talking about wine, beer and sci-fi and horror movies. Collins brewed beer and made wine at home for eight years. Feldt

was also an active homebrewer. In 2012, Feldt brewed beer for Collins's wedding while Collins made the wine. The duo realized that they wanted to pursue their craft on a larger scale. From the confines of cubicles, they developed plans to open a brewery.

The co-owners worked full time and dedicated additional hours each week to their venture. They devoted fourteen months to plan, research, develop their business concept and build the brewery. Once the Big Rip opened, demand quickly exceeded supply. The brewers prefer developing beers with more malt and sweetness rather than brewing a "bone dry" version of traditional styles.

Within the first year, Big Rip expanded production from a two-barrel system to four barrels. That upgrade boosted capacity from 120 barrels per year to 500 barrels. The owners gradually added eight part-time staff and expanded taproom hours to four days a week. In 2015, the Big Rip produced 275 barrels of beer primarily consumed at the taproom. The brewery does sell growlers and limited-release beers in bottles, such as ORC (oatmeal raisin cookie) Brown Ale and Twins Cherry Cheesecake Ale.

The owners signed a distribution deal in February 2016 with NKC Beverage Company for local distribution of twenty-two-ounce bottles and limited keg sales of their Scotch Ale, West Coast IPA and specialty beers. The Big Rip's owners anticipated distributing select beers in cans and upgrading equipment in the brewhouse in upcoming years.

The names of the brewery's beers are references to horror and science-fiction films and television shows, a nod to the owners' cultural tastes. Even the brewhouse tanks Ripley (*Alien*), Mulder (*X-Files*), Vader (*Star Wars*) and Ash (*Evil Dead*) are named after specific characters. Popular taproom beers include Aisle 12 West Coast IPA, an *Army of Darkness* reference; flagship Hathor's Sweet Brown Ale; 237 Milk Stout; Franklin Road Coffee Porter; and Hefe the Killer, a hefeweizen. The brewery also offers fruit-based gluten-free beers, homemade nonalcoholic root beer and sarsaparilla and barrel-aged beer, such as the Sour Sweet Brown Ale with cherries aged in a Pinot Noir wine barrel.

The Big Rip hosts an annual Get Ripped Brew Fest in June to celebrate its anniversary. The brewery added an event space in 2015 to its building, expanding its overall footprint to five thousand square feet.

2013: Cinder Block Brewery

Bryce Schaffter and his wife, Ashley, founded Cinder Block Brewery (110 East Eighteenth Avenue, North Kansas City, cinderblockbrewery.com) in September 2013. Schaffter was a homebrewer for five years before he decided to open a commercial brewery with the support of friends John and Jaime Baikie. John met Schaffter at a beer tasting in Schaffter's basement. After Baikie joined Schaffter in some weekend brewing sessions, the duo brewed batches of beer in preparation for KC Nanobrew Fest and the Great Nebraska Beer Fest. Once Schaffter decided to open Cinder Block, Baikie agreed to support the project and helped with construction of the brewery and taproom.

Brewmaster Bryan "Bucky" Buckingham, a native of Klamath Fall, Oregon, attended the University of Kansas in Lawrence, Kansas. His first brewery job involved washing dishes and tending bar at Free State Brewing in Lawrence. He moved to Kansas City and worked as a server and bartender at 75th Street Brewery in Waldo. Eight months after professionally brewing his first batch of beer, Buckingham became head brewer at 75th Street. He worked at the company from 2001 to 2006. Next, Buckingham helped to

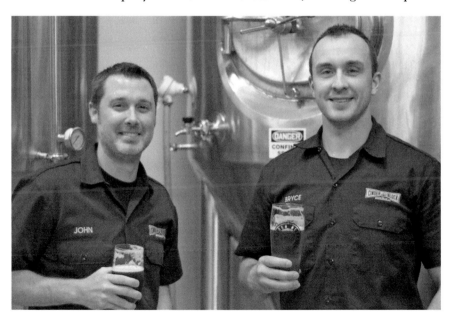

Cinder Block Brewery's John Baikie and founder Bryce Schaffter. *Photograph by Pete Dulin.*

open Power Plant Restaurant and Brewery in Parkville as front of the house staff and bar manager. Briefly, he was also a bartender at River Market Brewing Company. He was hired to open another branch of 75th Street Brewery (which became 23rd Street Brewery) in Lawrence and remained there from 2007 to 2013. Baikie and Schaffter met Buckingham at the 2013 Great Nebraska Beer Fest. Buckingham, who had two decades' worth of experience in the beer business, joined Cinder Block in 2013 as brewmaster and director of brewing operations.

Buckingham described Cinder Block's selection of beers as "well-rounded with a bit of everything." He said, "We have American, Belgian and English styles of beer, cider, a barrel-aging program, sour beers and the Hop Maven series."

Cinder Block's flagship beers include Northtown Native, a crisp California Common ale; Block IPA, brewed with six different hop varieties; Prime Extra Pale Ale; Pavers Porter; Rivet Rye Wheat; and Belgian Weathered Wit. The brewery makes French apple cider and English cherry cider. Its rotating Hop Maven series highlights different hop varieties in IPAs.

Seasonal and limited releases include Black Squirrel Russian Imperial Stout, aged thirteen months in a whiskey barrel. The beer is named after a mysterious squirrel that made appearances outside the brewery. Other releases include Cinder Noel, a Belgian strong ale winter warmer; Coffee Hop'd, an English brown ale made with local coffee; and KC Weiss, a tart take on Berliner weiss. The brewery teamed with Jax Fish House in January 2016 to brew an oyster stout, using the restaurant's proprietary Emersum oysters, and its version of the unusual beer style was released the following month.

Cinder Block's inventory of fifty-four bourbon, brandy and wine barrels in the taproom is used to age certain beers and ciders. Each barrel is marked in chalk with anticipated release dates that depend on how the beer ages over time, subject to testing, anywhere from eight to eighteen months.

The brewhouse is packed with a 15-barrel system, three 15-barrel fermenters, one 30-barrel fermenter, two 15-barrel brite tanks, one 30-barrel brite tank, four 15-barrel serving tanks and three 7-barrel serving tanks. Overall annual capacity is 2,500 barrels. Volume rose from 438 barrels in 2014 to 667 barrels in 2015 and a projection of more than 1,000 barrels in 2016.

The brewery expanded its overall footprint within its building to add storage and production space. In the summer of 2015, it opened a patio and event space called the Reclamation Room, providing an additional three

thousand square feet for games and entertainment. The event space features a window with a view of the two-person manual canning line, pilot system and in-house coffee roaster. In December 2015, Cinder Block began selling limited supplies of its core beers in four-packs of sixteen-ounce cans.

Cinder Block also began distributing Northtown Native, Block IPA and Rivet Rye in kegs in March 2015 to Kansas City–area bars and restaurants. NKC Beverage Company handles distribution to clients throughout the metro.

2013: Rock & Run Brewery and Pub

A chance meeting between a rock band leader and an ultra-marathon runner led to the formation of Rock & Run Brewery and Pub (110 East Kansas Street, Liberty, rockandrunbrewery.com) near historic Liberty Square. Vocalist and bassist Gene DeClue performs in funk cover band Cherry Bomb. He has brewed beer at home for twenty years. Runner Dan Hatcher met DeClue by chance even though the two men lived only a half block away from each other in Liberty.

DeClue was drinking beer one evening in his driveway. A woman walking her dog started conversing with the homebrewer. She mentioned that her boyfriend, Dan, was interested in brewing. The men met two weeks later. They began to brew at home together and exchanged ideas for an actual brewery, agreeing that an opportunity existed to introduce craft beer to Liberty.

"I've always had the entrepreneurial spirit, and not wanting to shy away from a challenge, we decided to see if we could put together a plan for a local brewery," Hatcher said. "We both felt like the time was right for this venture."

"It had been in the back of my mind to do this professionally six months after I started homebrewing," DeClue said. "The notion was there, but it would take time and money."

DeClue built a pilot brewery in his garage to test expanded production. They invited investors, presented their business plan for a brewpub and poured generous beer samples. Hatcher and DeClue also held meetings with government officials and community leaders about their proposal. A brewery and pub opening in a historic building was an unprecedented venture. Once funding, clearances and permits were secured, DeClue and

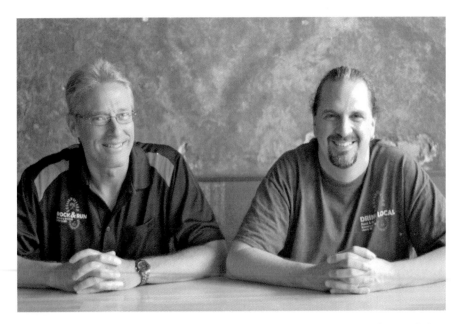

Rock & Run Brewery and Pub co-founders Dan Hatcher and Gene DeClue. *Photography by Pete Dulin.*

Hatcher bought a building near Liberty Square in May 2013 and opened the brewery doors in December that year. DeClue manages brewhouse production while Hatcher oversees business operations.

The restaurant added to the size, scope and staffing of the brewpub, moves that were necessary to make the business plan viable. Revenues from food and beer sales offset the brewery's overhead and generated income.

DeClue and Hatcher tore down a wall between two one-hundred-year-old buildings to create a 3,200-square-foot downstairs venue. That space housed a 1-barrel brewhouse, kitchen, bar and dining area. The brewhouse size was limited by the available footprint within the historic building, where extensive renovation wasn't feasible. DeClue and his assistant brewers produce up to four batches a day, turning out 8 to 12 barrels each week. Rock & Run brewed 460 barrels in 2014 and 420 barrels in 2015, the lesser amount due to longer fermentation time for some of its beers.

DeClue built the pub to handle sixty taps. Currently, the brewery offers thirty unique taps for a rotation of thirty U.S. craft beers. Another ten taps are dedicated to in-house beers. Core beers include Liberty Squared, an ale that drinks like a lager to appeal to macro beer drinkers; unfiltered Farmhouse Funk dry-hopped with Sorachi Ace hops; 5K IPA; Ryely Porter; rotating

hop series Pale Ale; and Saminator, a quadruple IPA fermented a second time with sake yeast and honey. Named after DeClue's youngest daughter, Samantha, Saminator clocks in at 14.3 percent ABV (alcohol by volume) and a whopping 155 IBU (international bittering units). The brewery offers many rotating seasonal beers in varying styles and flavors. As of 2016, Rock & Run's beers are only available on tap or as growler fills, but the owners have plans to increase availability.

In early 2016, DeClue and Hatcher initiated plans to expand by the following year into a long-vacant space in the building next to the brewery. The building collapsed. Proposed future expansion plans include a new seven-barrel brewhouse, four seven-barrel fermenters, four four-barrel fermenters, a dedicated taproom with ten taps for Rock & Run's beers and two additional taps and an event room. Beer will be drawn from twelve new serving and conditioning tanks rather than kegs. The original one-barrel system will be used as a pilot system for test and limited-edition beers. An expanded space will enable Rock & Run to establish a barrel-aging program for cider, mead and beer. The space will also be used for events, tastings, classes and meetings for its brewery club members.

This expansion enabled the brewery to boost its annual production capacity from 500 barrels to between 1,000 and 1,200 barrels. The greater volume enabled service of in-house customers and self-distribution of kegs in the Greater Kansas City area. After testing market demand for its kegged beers, Rock & Run's owners envisioned widespread distribution in years ahead.

2014: Kansas City Bier Company

Steve Holle, founder of Kansas City Bier Company (310 West Seventy-ninth Street, kcbier.com), saw a prime opportunity. He wanted to offer an alternative to the English, Belgian and American styles of craft beer available in the retail market. He sought to produce and distribute classic German styles in large volume that were fresh, easy-drinking and widely accessible throughout Kansas City.

In the early 1800s, immigrant Germans brought knowledge of their native beer styles, mostly lager, to the U.S. brewing industry and popularized those recipes. In fact, German-born Peter Schwitzgebel was the first known brewer in Kansas City in the late 1850s to offer lager and "white beer." Post-

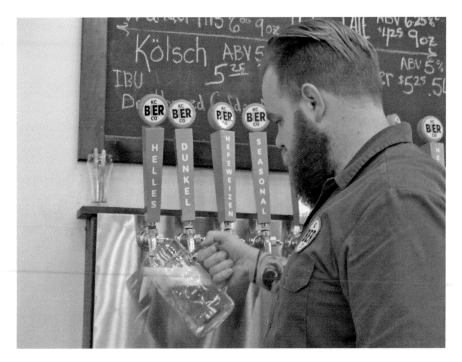

Kansas City Bier Company specializes in traditional German styles of beer such as helles, a pale golden lager, and dunkel, a dark lager. *Photograph by Pete Dulin.*

Prohibition, original German lager recipes were altered, brewed and offered by macro brewers that still sell familiar brands today.

Holle intended to take an artisan approach to German-style craft beer that no one else brewed. And other than Boulevard Brewing, no other local brewery at the time had plans to operate a large production facility with a focus on distribution as its business model. Less than two years later, Holle's instincts about market demand for German-style beers prove astute.

Kansas City Bier Company brewed its first batches in mid-December 2013 and opened for business in February 2014. It does not operate as a brewpub model, where a full-service restaurant has a brewery on premises. Designed as a large-scale production brewery, Kansas City Bier is connected to a taproom and bier hall that Holle envisioned as a showcase for its beers. If customers tasted Kansas City Bier's offerings on site and found a favorite beer, then they might be more inclined to order the beer on tap at local bars and restaurants, he reasoned. Today, the brewery's beers are available on tap at more than 425 area locations.

Prior to opening Kansas City Bier in the Waldo neighborhood, Holle went to great lengths to work with the city council and secure a tavern license to sell beer by the glass in its tasting room. He petitioned the council to exempt microbreweries that weren't operating like a typical bar operation. Holle argued that the brewery was more of a manufacturing operation and the tasting room was a showcase for its products. He also had to secure a wine manufacturer's license to sell beer by the glass since a microbrewery with a wholesale manufacturer's license was not allowed to sell beer by the glass or in cans or bottles on site by Missouri law. As such, Kansas City Bier must produce at least two hundred gallons of fermented fruit juice—in its case, cider—to maintain the wine manufacturer's license. Kansas City Bier prevailed over regulations so it could ultimately sell its German-style beer on site.

Holle's father spoke German and enjoyed beer. Holle studied this second language in high school, double majored in business and German in college and spent a semester in Hamburg. There, he developed an appreciation for German beer. He earned a diploma in brewing and wrote *A Handbook of Basic Brewing Calculations* (for brewers) and *Beer Steward Handbook: Beer Sommeliers* (for beer sellers), published by the Master Brewers Association of the Americas. Holle, former director of St. Louis–based Urban Chestnut Brewing Company, has also traveled extensively to Bavaria to study Germany's beer culture and brewing methods.

After a thirty-three-year career in commercial real estate investment and banking, Holle retired and moved from Dallas to Kansas City. Along with friend and Bavarian native Juergen Hager, he secured enough investors to commence with the business plan for the brewery. They hired brewer Karlton Graham, a graduate of the Siebel Institute's Master Brewer Program and student at the Doemens Akadamie in Munich, Germany, to head brewery operations.

Kansas City Bier follows the German Purity Law (*Reinheitsgebot*), a consumer food protection law enacted in 1516 in Bavaria to control the quality of beer by limiting the ingredients in beer to water, hops and barley with the later addition of yeast. About 75 percent of the beer that Kansas City Bier brews are lagers that require cold fermentation and long aging times. This increases the cost of production because fermentation requires more tanks and more refrigeration. The brewery uses malts direct from Kulmbach, Bavaria, and hops from Seitz Farms in the famous Halllertau Valley to produce authentic-tasting German beer.

Kansas City Bier's beers on tap include bestselling Dunkel, a dark lager; Helles and Hefeweizen that are sold year-round; plus seasonals such as Pils, Doppel Alt, Festbier made for Oktoberfest and Winter Bock. The

brewery has also brewed American interpretations of German styles that have included dry-hopping and oak-aging. A limited release Der Bauer, a farmhouse ale, was more of a German interpretation of a Belgian style. The taproom typically has six to nine styles available.

In 2015, Kansas City Bier sold 4,500 barrels and anticipated doubling that volume in 2016. The brewery has steadily added more fermenters, brite tanks and other equipment to increase its annual capacity to 12,000 barrels in volume. The brewery is also adding a bottling line to provide packaged beer to area retailers. Distribution is focused on serving the Greater Kansas City market.

2014: TORN LABEL BREWING COMPANY

Torn Label Brewing Company (1708 Campbell Street, tornlabel.com) opened its nearly seven-thousand-square-foot outpost in December 2014 in the east end of the Crossroads Arts District. Chief Executive Officer Rafi Chaudry and head brewer Travis Moore partnered with Chad and Carol Troutwine, who have distribution experience in the beer industry, to develop the brewery. Torn Label is located in the Studio Inc. building, a nonprofit artists' workspace and exhibition center.

Chaudry and Moore, both homebrewers, first met randomly at Overland Park coffee shop Daily Dose and bonded over beer. Chaudry grew up in Overland Park, and Moore is from Olathe, Kansas. They each worked out of state and returned to the Kansas City area. Chaudry spent eight years producing films in Los Angeles. Moore, who graduated from law school in Chicago, decided to shift away from practicing law. He had also spent time traveling and researching beer in Belgium. The duo shared a goal of professionally brewing their own beer. As new local breweries appeared, Chaudry and Moore felt the timing was right to stake a claim in Kansas City's brewing community.

Each co-owner brought a knowledge of brewing and the craft beer audience in Los Angeles, Chicago, San Diego, New York and Belgium, based on their travels. They chose to open a production brewery with enough scale to distribute rather than a brewpub concept. By July 2015, Torn Label had opened a popular tasting room on site with a capacity of thirty people.

The brewery's fifteen-barrel system also includes three fifteen-barrel fermenters, two thirty-barrel fermenters, one fifteen-barrel brite tank and one thirty-barrel brite tank.

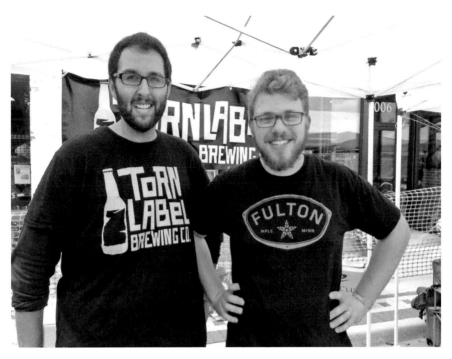

Torn Label Brewing's co-founders Rafi Chaudry (*left*) and Travis Moore poured samples at the 2014 High Plains Brewhoff beer festival. *Photograph by Pete Dulin.*

"We chose that system because it allows us to do our three flagship beers often (by double-batching into the thirty-barrel fermenters and brite)," Chaudry said, "while also allowing enough capacity for adventurous and experimental seasonal, rotational and barrel-aged offerings."

While the brewery's annual capacity is 2,500 barrels, the initial production target was 1,200 barrels in the first year. Additional tanks can be added to Torn Label's building in order to triple brewing capacity as needed.

Torn Label fashions itself as an American-style craft brewery that puts a spin on classic old-world styles. Its flagship beers include Alpha Pale, a super-hopped but sessionable pale ale; House Brew, a coffee wheat stout dosed with Sumatran toddy from Thou Mayest Coffee Roasters; and Monk & Honey, a Belgo-American single brewed with honey from Peculiar, Missouri. Monk & Honey was inspired by Moore's travel and visit to a Belgian monastery, where a similar style is brewed by monks.

Hang 'Em High, a West Coast–style IPA; Quadjillo, a Belgian Quadrupel brewed with guajillo chiles; Tonguelash, a bracing and tart kettle-soured hoppy wheat; and Old Believer, a boozy Russian imperial stout, are a few

limited-edition beers released in 2015 to local taprooms. The debut selection in the Artist Series was Lumber Lung, an oaked brown ale made with locally harvested and toasted white oak in collaboration with artist Peter Warren, who also designed Torn Label's woodsy-meets-urban taproom decor.

During its first full year of operation, Torn Label signed with Major Brands, and distribution of its beer in kegs began in Missouri in January 2015. The deal gave Torn Label the distinction of being the first Kansas City, Missouri brewery with statewide distribution since Boulevard Brewing Company. However, most of Torn Label's distribution is concentrated around hometown bars and restaurants, with future plans to distribute across the state. The brewery also signed in March 2015 with Standard Beverage Company, which began distributing its kegged beer in Wyandotte and Johnson County, Kansas. The Kansas distribution deal meant that Chaudry and Moore's beers would be available in their old stomping grounds at venues where they first explored craft beer years earlier.

2014: CRANE BREWING COMPANY

Founded as a company in 2014, construction began on Crane Brewing (6515 Railroad Street, Raytown, cranebrewing.com) in the spring of the following year. The production brewery officially opened in September 2015 in a white cinder block building. However, the earliest incarnation for the brewery began in co-founder Michael Crane's basement. Crane started brewing with a newly purchased Mr. Beer kit at his Leawood, Kansas home in 2009 as a fun activity to do with his adult sons, despite rarely consuming alcohol himself.

Crane experimented avidly with brewing wild ales, saisons and other beer styles using wild yeast he collected from blueberries, wildflowers and other sources. In time, Crane entered his beers in competitions at St. Louis, Minneapolis and other cities, accumulating numerous awards and a growing fan base. Fellow homebrewers at the 2013 KC Nanobrew Festival vied for samples of Crane's Magenta Berliner Weiss, made with beets, before the festival opened to the public. Crane was encouraged to start his own brewery but shied away from the daunting venture.

During that time, Crane owned Funblock, Inc., a company in Raytown that manufactured classroom and storage furniture for more than two decades. Funblock recovered slowly from a stunted post-9/11 economic

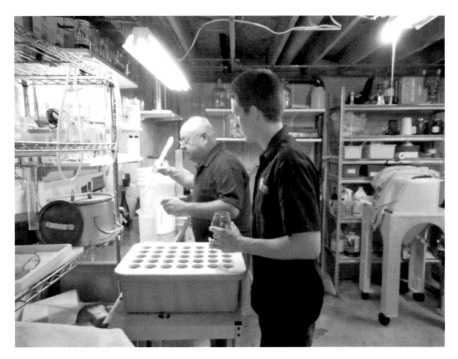

Michael Crane (*left*) and Christopher Meyers tested early homebrewed beer recipes in Crane's basement before Crane Brewing officially opened, circa 2014. *Photograph by Pete Dulin.*

climate. In 2013, the company lost a major client. Further, KC Closet, a tenant that occupied half of the space in Funblock's eighteen-thousand-square-foot building, decided to relocate. These developments prompted Crane to reconsider conversion of his building into a brewery. Crane had a building to base his operation, award-winning beers, a small fan base and encouragement from a distributor. Yet he was reluctant to start another business by himself.

Christopher Meyers, a homebrewer with a background in biology, saw a newspaper article about Crane and his beers. Meyers had been working in veterinary medicine, mostly in practice management, for almost a decade and had already applied to vet school. He left the field and his last practice at Rainbow Pet Hospital in September 2015 to open Crane Brewing.

Meyers had been developing plans with brewer Steve Hood, who worked briefly at Boulevard Brewing Company and graduated from the American Brewers Guild, and Aaron Bryant, a homebrewer and chemical engineer, to open a brewery in Lee's Summit. Meyers and his team met with Crane

and his friend Randy Strange, a homebrewer and geologist who later graduated from the Siebel Institute of Technology. The group joined forces and launched Crane Brewing in Raytown together. The company includes Crane, co-founder and president; Meyers, co-founder and vice president; Hood, head brewer; Strange, brewer; Bryant, operations manager; and Jason Louk, chief executive officer.

Crane's basement became a laboratory to refine recipes and produce test batches. Under its official name, Crane Brewing Company first appeared at the 2014 Parkville Microbrew Fest. Crane received high praise for his saison at the festival from award-winning Blind Tiger brewmaster John Dean. Crane Brewing, which was still a homebrewing operation, exhausted its fifty-gallon supply within hours.

Crane became injured at the beer festival when a knob on a carbon-dioxide cylinder broke. The cylinder spun uncontrollably before it impacted Crane's arm and shattered bone. After treatment at a hospital, Crane left with a five-inch plate in his arm as a memento of the experience. Still, Crane Brewing's promising debut boded well for plans to open a production brewery.

Crane Brewing received clearance to open its brewery in Raytown after the city council unanimously agreed to revise existing zoning laws and accept breweries as a light manufacturer. Demolition and construction of the brewery began in the spring of 2015. By its September 2015 opening, the brewery featured a fifteen-barrel two vessel, steam-jacketed brewhouse. Additional equipment includes a thirty-barrel hot liquor tank, three thirty-barrel fermenters, two fifteen-barrel fermenters, two carbon filters, a keg washer, a thirty-barrel brite tank, a fifteen-barrel brite tank and a six-head gravity wine filler bottling unit. The building has space for grain storage, a dedicated room with eighteen barrels used for aging and fermentation, a laboratory, bottling and shipping and room for a future event space and taproom.

The brewery initiated a crowdfunding campaign in the spring of 2015 through CrowdBrewed with a goal to raise $40,000. The campaign netted $45,705 from 296 backers. Funds were allotted for additional wine and spirits barrels, kegs and testing equipment. Crane Brewing hosted the beer-centric Festival of the Lost Township in September 2015 on Labor Day weekend. Because it had not yet received state approval for production, the brewery didn't serve its own beers at the inaugural festival.

Crane Brewing focuses on three styles: saison, lambic and Berliner weiss. The brewers use various hops, wild yeast, souring bacteria, barrel-aging, specialty malts and adjuncts such as apricot.

Eight months before the brewery opened and began brewing, Crane Brewing attracted the attention of several local and national distributors. The brewery's founders selected Central States to distribute kegs and 750-milliliter bottles of its beer. Saison, Farmhouse IPA, Orange Gose and Apricot Weiss were the first Crane beer styles to launch. Crane Brewing planned to brew three thousand barrels in its first full year of production.

Distribution of Crane's beers began in December 2015 to Kansas bars and restaurants. Missouri distribution followed in January 2016 after backlogged officials approved labeling. Crane Brewing's taproom opened in 2016.

2015: Border Brewing Company

Border Brewing Company founder Eric Martens in the taproom. The brewery is one of four that have opened on or near East Eighteenth Street between February 2015 and the spring of 2016. *Photograph by Pete Dulin.*

When it opened in February 2015, Border Brewing (406 East Eighteenth Street, borderbrewco.com) was the first of several breweries that now form Brewery Row in the east side of the Crossroads Arts District. Border's neighbors include Double Shift Brewing Company, Torn Label Brewing Company and Brewery Emperial.

Homebrewer Eric Martens and his wife, Tracy, invested much of their life savings and retirement to build the 1,750-square-foot brewery and forty-two-seat taproom. They are backed by silent investors as well. Martens, a homebrewer for eight years, earned a chemical engineering degree from Kansas State University. After working as a chemical engineer for six years, he resigned to open a brewery.

The Martenses founded the company in 2013 and spent months seeking a downtown location in Kansas City. They found a spot on busy East Eighteenth Street near local restaurants, an outdoor music venue and galleries. The area generated high foot traffic, especially when First Friday gallery outings drew crowds.

A view of Border Brewing's taproom from East Eighteenth Street. *Photograph by Pete Dulin.*

The brewery's name refers to the Missouri-Kansas border. According to Martens, the name also alludes to being "on the 'border' between commercial styles of beer and extravagant craft brew."

"We want to make styles that are approachable but interesting," Martens said. "Our goal is to provide a product that people who are new to craft beer will enjoy, as well as those who are already into the craft world."

Rotating session beers on tap include Patio Extra Pale Ale, Backyard Blonde Ale, Campfire Porter, Rooftop Red Ale, Double IPA and Chocolate Milk Stout. Border's "We Brew for You" program invites customers to vote monthly on the next seasonal or limited-edition beer style that Martens will brew and serve on tap. Extra Special Bitter (ESB) on nitrogen and Rye IPA are two such styles.

2015: Double Shift Brewing Company

Founded by Aaron Ogilvie, Double Shift Brewing (412 East Eighteenth Street, doubleshiftbrewing.com) opened in June 2015 next to Border Brewing. Double Shift refers to Ogilvie's dual role as brewery owner and firefighter. He has worked full time at the Leawood Fire Department for more than five years. Ogilvie has also spent many hours on the "second shift" to get the brewery operational.

Ogilvie learned to brew while studying at Kansas State University. He continued to develop recipes after graduating. He committed to opening a brewery in 2013 and spent five months writing, refining and vetting a business plan through entrepreneurial programs at the University of Missouri–Kansas City and Ewing Marion Kauffman Foundation. Ogilvie devoted two months to lining up investors. He has four silent partners in the venture. Finding the 2,500-square-foot building that would house the brewery became an eight-month search—far longer than the two weeks he had allotted. The Crossroads location provided the heavy foot traffic and population density that Ogilvie sought. He signed a lease in October 2014 and began construction on the brewery and taproom the following February.

Double Shift Brewing Company founder Aaron Ogilvie. The brewery's name reflects Ogilvie's dual occupations as a brewer and firefighter. *Photograph by Pete Dulin.*

Ogilvie planned to brew up to 350 barrels in 2016 on the all-electric, 5-barrel brew system. The brewhouse also contains two 5-barrel fermenters and two 10-barrel fermenters. Ogilvie intends to gradually increase annual production to 1,000 barrels. He hired Bryan Stewart, also a homebrewer, to assist with brewing operations. Stewart is enrolled in the Siebel Institute's craft brewing theory program.

Double Shift's core beers include Summer Session White IPA, Run-Around Rye Ale, Heavyweight Double IPA, Hayloft Saison and 18th Street Pale Ale. Stewart and Ogilvie collaborate on flagships and ongoing production, but Stewart has leeway to develop seasonal beers such as Turk

Kahvesi, a sweet stout with cardamom and locally roasted coffee. Briar and Bramble English Ale features hops from the United States and United Kingdom. Rye whiskey barrels from Union Horse Distillery are used for barrel-aging beers. In 2016, the brewery planned to release six limited-edition beers in bottles available at the taproom.

2015: RED CROW BREWING COMPANY

The inspiration for Red Crow Brewing Company (20561 South Lone Elm Road, Spring Hill, Kansas, redcrowbrew.com) was born around 2010 after Chris and Mistie Roberts shared some of his brewed beer with Mistie's parents, Joe and Loretta Fisher. Five years of planning, raising investment, searching for a suitable location and building followed. Red Crow Brewing opened its doors in October 2015 outside Olathe. Chris Roberts leads brewing operations, Mistie manages the day-to-day business, Joe assists with brewing and Loretta handles accounting. The foursome share ownership in the brewery.

Red Crow's 3,200-square-foot brewery is divided into a spacious taproom, brewhouse, cold room, office, laboratory and storage. The taproom's garage doors open to reveal a spacious, multi-level patio with seating at picnic tables and chairs, plus landscaped grounds and farmland in the distance. The brewery is housed in a building developed by design/build firm Artistic Concrete Surfaces.

The initial 7-barrel brew system included two 7-barrel fermenters. Annual production capacity is 350 barrels. Roberts added two 7-barrel brite tanks in February 2016, doubling cellar capacity. Short term, the goal is to add up to two 15-barrel fermenters and one 15-barrel brite tank by mid-2016, which would increase annual capacity to 700 to 1,000 barrels. Long term, Red Crow aims to upgrade to a 15-barrel system by early 2017 and add two 30-barrel fermenters and two 15-barrel fermenters, the maximum amount of equipment that would fit in the existing space. At that stage, annual capacity would reach 2,250 barrels.

The beers are named after influential women in the lives of the Robertses and Fishers. Isabelle contains barley and wheat malt blended into a soft Belgian blonde ale. Elaine, a rye porter; Louise, an India pale ale; Donna, an American wheat; and Frances, a pale ale, compose the flagship session beers. Seasonal beers include Margaret, a winter old ale; Elizabeth, a spring

Red Crow Brewing Company owners Joe Fisher, Loretta Fisher, head brewer Chris Roberts and Mistie Roberts opened a brewery and taproom in Spring Hill, Kansas. *Photograph by Pete Dulin.*

saison; Norma Jean, a pomegranate wit; and Anne, a fall release German alt bier. Roberts hopes to add a cider in 2016, pending legislative changes in Kansas that would allow production.

A rotation of food trucks makes scheduled appearances during opening hours. The taproom regularly hosts live music. While there's no back story to the brewery's name, the logo design featuring a crow evokes breweries of yesteryear. The crow's name is Clancy.

Lone Elm Road, where Red Crow Brewing is based, is named for one specific tree. Travelers and traders on the Oregon, California and Santa Fe Trails rested at Round Grove Campground, where a grove of elm trees and a spring provided suitable conditions for livestock grazing. A steady influx of campground visitors cut down all the trees for firewood except for one elm tree. In 1844, Round Grove Campground was renamed Lone Elm Campground and remained a recognizable landmark to westbound pioneers. Today, Red Crow Brewing is a pioneer brewery in southern Johnson County and a destination for beer lovers headed south on 69 Highway toward Lone Elm Road.

2016: CALIBRATION BREWERY

Calibration Brewery (119 Armour Road, North Kansas City, calibrationbrewery.com) is scheduled to open in the summer of 2016 in an 8,500-square-foot building. Along with Cinder Block Brewery and The Big Rip Brewing Company, it is the third brewery to open in North Kansas City in the past three years. Calibration's building was formerly home to Northland Collision Center, a barber and beauty shop and an automotive dealership.

Glen Stinson, a plumber by trade and owner of Northland Plumbing, owns the building that houses the brewery. Stinson, who underwrote the brewery venture, started homebrewing with his son, Nic, about twenty-five years ago. Brewmaster Pat Sandman oversaw the brewery's construction and leads brewing operations. Amanda Harris was hired as general manager of Calibration.

Initially, Stinson contacted Cinder Block's brewmaster Bryan Buckingham for recommendations on brewers. Buckingham introduced Stinson to Sandman. The two discussed the brewery venture and agreed to terms. Sandman, former brewmaster at 75th Street Brewery, learned the trade from his predecessor and brewing mentor, Micah Weichert.

Prior to opening, Sandman explained that Calibration's core beers will include hop-forward selections (IPA, West Coast IPA, pale ale), malt-forward options (Irish red, stout) and wheats (hefeweizen, Belgian wit). After being open a few months, Sandman anticipated brewing and releasing seasonal beers.

Calibration's setup includes a seven-barrel system, an icehouse for six tanks and room for a hot liquor tank, mash tun, three seven-barrel fermentation tanks and a fifteen-barrel fermentation tank, plus a pair of conditioning tanks. The brewery's space houses offices, a grain room, a mill room, a boiler room and event space. A patio, parking and outdoor game area extend Calibration's outdoor footprint.

Sandman planned to distribute at least two of Calibration's beer styles in the future. He has a loading bay door and space built for that purpose by the brewhouse.

2016: Brewery Emperial

Brewery Emperial (1829 Oak Street, breweryemperial.com) brought together talent from Kansas City's restaurant and brewery worlds into one venture. Room 39 chef/owner Ted Habiger and master brewer Keith Thompson (McCoy's Public House, 75th Street Brewery), along with fellow co-owners Rich Kasyjanski and Keith's wife Julie Thompson, opened one of the city's most anticipated new breweries in 2016. The owners possessed a wealth of experience and knowledge of brewing, food and hospitality, as well as connections to patrons and resources city-wide.

Habiger and Thompson worked together in 1994 as servers at 75th Street Brewery, where Thompson's brewing career began. Thompson opened McCoy's Public House when it launched in 1997 and continued as head brewer until 2014. Through 2015, he consulted for the brewpub that composed a significant part of his legacy and local brewing history. Thompson's wife, Julie, helped to open The Foundry, a craft beer bar located next to McCoy's. Kasyjanski, who won a $19.6 million Powerball jackpot in 2001, was a former bartender who also helped to open McCoy's. He retired from teaching math at Wyandotte High School.

Habiger and his wife, Jackie Kincaid Habiger, own and operate two locations of Room 39 on West Thirty-ninth Street and in Leawood's Mission Farms. They also own Sasha's Baking Company. Habiger's résumé includes cooking at Café Allegro and 40 Sardines in Kansas City and as sous chef at Danny Meyer's famed Union Square Café in New York before opening Room 39 in 2004 with Chef Andrew Sloan.

Keith and Julie Thompson have dreamed about opening a brewery for ten years. Discussion of the idea with Habiger and Kasyjanski led to more collaboration. Excited about the depth of talent among friends, Kasyjanski described the timing of his decision to partner with the Thompsons and Habiger on the project as "capturing lightning in a bottle."

The group's location search, plans and timetable drifted beyond a year from their intended opening date, due to winter weather and other factors. Since early 2015, Thompson and Habiger had been devoted to converting a raw sixteen-thousand-square-foot space into Brewery Emperial.

The brewery's name is a subtle nod to Imperial Brewing, the historic, pre-Prohibition brewery located west of the Crossroads. The owl in the brewery's logo is an homage to Japanese brewery Hitachino Nest, the source of Brewery Emperial's brew system. Construction proceeded through the spring of 2016.

Brewery Emperial co-founders Ted Habiger (*left*) and Keith Thompson discuss plans for the brewery on the construction site at night by a wood-fired stove, January 29, 2016. *Photograph by Pete Dulin.*

Along with the four-vessel, fifteen-barrel brew system from Hitachino Nest, Brewery Emperial also purchased six thirty-barrel fermentation tanks and a dozen thirty-barrel brite tanks made by Custom Metalcraft in Springfield, Missouri. The brewpub encompasses a brewhouse, a cooler, fermentation tanks, space for shipping, a taproom, a bar, a kitchen and in-house dining. Outside, a thirty-five-foot-high grain silo rises above the open-air biergarten. The building's walls feature local artist Scribe's signature animal-based characters, including an owl and rabbit, in colorful graffiti murals. His older murals existed before the brewery and were preserved to reflect the Crossroads' history of independent arts and street culture.

The restaurant offers a mix of elevated pub food, charcuterie and family-style dishes. The farm-to-table menu has locally sourced meats and vegetables prepared on a wood-fired grill. Habiger's inspiration for this style of cooking dated back to his days at Café Allegro; the cuisine at El Pollo Rey in Kansas City, Kansas; wood-fired cooking at Camino in Oakland, California; and Argentine chef Francis Mallmann's approach to cooking

over live coals. Habiger and Thompson acquired three grills and a smoker from the original Golden Ox steakhouse in the West Bottoms for use in the brewery's kitchen.

Thompson's selection of beer styles includes lagers, an Extra Special Bitter (ESB), farmhouse saison and other styles that pair well with grilled foods.

2016: Stockyards Brewing Company

Brewer Greg Bland, financier Ray Kerzner and creative director Brendan Gargano, co-founders of Stockyards Brewing Company (1600 Genessee Street, #100, stockyardsbrewing.com), brought modern brewing with a blue-collar work ethic to the historic West Bottoms. To secure the space, Bland worked with gallery owner Bill Haw Jr. and Haw's father, Bill Haw Sr., whose family owns and has developed many Stockyards District properties. The co-founders signed a lease in 2015 and commenced building a brewery and taproom with eighty-person capacity in a section of the Golden Ox restaurant and lounge, an iconic steakhouse destination that closed in December 2014.

An exterior view of Stockyards Brewing Company at 1600 Genessee Street, which inhabits a portion of the original Golden Ox Restaurant in the West Bottoms, circa 2016. *Photograph by Pete Dulin.*

Founded in 1949 and located on the first floor of the Livestock Exchange Building, the Golden Ox symbolized the long-gone heyday of the stockyards. Bland, who was raised in Red Lodge, Montana, identified with ranch life, where cattle drives ran from his home state to Texas. The Stockyards District and Golden Ox reminded Bland of his childhood home and Montana steakhouses, providing a natural setting for the brewery. Stockyards Brewing joined an ongoing West Bottoms revival that includes the presence of Amigoni Urban Winery, restaurants Genessee Royale and Voltaire and dive bar Lucky Boys. The Golden Ox restaurant will return in a smaller footprint within its original space under new ownership by the owners of Voltaire.

Construction delays pushed back Stockyards' plans from a fall 2015 to a spring 2016 opening. The space underwent significant changes to accommodate the brewery's equipment, grain storage and milling and other facilities. The brewery and taproom retained many key features of the former Golden Ox, including use of a massive sixty-five-year-old wooden door once used in the restaurant's meat locker, stained-glass windows, mahogany woodwork, reupholstering of the original booths, carpeting, bar armrest railings and the front bar, now topped with zinc and rigged for twelve taps. A black leather Brewers' Booth in the back of the brewery is reserved for meetings and socializing. A large photograph of the stockyards in its heyday is mounted in the hallway. Opposite, glass windows offer a view of the brewery's equipment and operations.

While Bland has been a homebrewer for nearly ten years, the Stockyards' team sought additional expertise to launch its brewery. They hired Micah Weichert, brewmaster at Gordon Biersch, as a consultant for installation and brewing. After the brewery launched, Stockyards hired Weichert as its full-time head brewer to run daily operations.

The fifteen-barrel, three-vessel system was built by American Brewing Equipment. Additional brewhouse equipment includes five fifteen-barrel brite serving tanks, four fermentation tanks, a hot liquor tank and a cold liquor tank.

Golden Alt; Black IPA; American-style Brunch Stout; Thunder Hef, a hefeweizen; and hoppy India Pale ale is routed directly from brite tanks to the bar taps. The bar serves seasonal beers and guest beers from other breweries on tap, plus cocktails, wine from Amigoni Urban Vineyard and coffee on tap. The brewery's first-year forecast for annual volume is five to seven hundred barrels with a capacity of one thousand barrels. Stockyards Brewing also hired Melissa VanGoethem of Coffee Girls Café as the taproom's bar manager.

Initially, Stockyards served its beers only at the brewery but plans to distribute kegs and possibly packaged beer in the future. The taproom serves a limited selection of cold and prepared foods such as charcuterie, pickled foods and "Southern homestyle provisions." Once Voltaire's owners reopen the refurbished Golden Ox, Bland anticipates offering select items from that kitchen.

The rebuilt venue includes an event space with the original 1910 marble tile floor and stained glass, a new bar with eight additional taps and a sound system.

Craft Beer in the Twenty-first Century

Kansas City's brewing industry has experienced sustained periods of vibrant growth and dry spells from the mid-1800s to the early twenty-first century, a span of more than 160 years. John McDonald of Boulevard Brewing Company and Chuck Magerl of Free State Brewing Company were the first contemporary pioneers in the area to act on the craft brewing trend during the late 1980s. The emergence of small-scale craft brewing in California, Colorado and elsewhere was significant beyond anyone's wildest imagination. Overall, brewing was overdue for significant growth and innovation from homebrewers and startups.

Boulevard Brewing became the largest production brewery in Kansas City and subsequently the region from the 1990s to the present day. Only a few local breweries and brewpubs have endured since the '90s as beer drinkers learned to appreciate and consume fresh, locally made beer. Meanwhile, craft breweries and beer selection began to flourish across the United States.

Not until the 2010s did a new class of homebrewers, professional brewers and entrepreneurs take the step of opening a brewery in Kansas City. This sudden spate of openings mirrors growth occurring in the craft brewing industry nationwide. Cities such as Portland, San Diego and Denver with a greater concentration of craft breweries have developed over many years. Kansas City's craft brewers and owners slowly developed plans and gathered resources, but they quickly established operations that uphold time-honored brewing tradition and embrace innovation.

The benefit of this long gestation period is that the city's brewers can tap into growing demand for high-quality, locally brewed beer. Brewers are not limited to one business model, marketing strategy or even predominant

style of beer. A thirst for variety reigns today. Craft beer communication has become more intertwined and sophisticated between craft breweries and consumers. Social media, digital apps on handheld devices, craft beer festivals, beer dinners, venues such as Bier Station and Flying Saucer, homebrewing groups and social groups such as Beer Tasting Kansas City that interact online and in person have fostered a dynamic craft beer community and culture in Kansas City. It shows no signs of slowing or reaching saturation anytime soon.

History continues to flow like water past riverbanks. The stories of modern breweries extend beyond these pages, especially in Kansas City.

Kansas City is a place to call home and to explore new frontiers by highway, rail, river current and jet stream. Lifelong residents and newcomers find that Kansas City is also a place for people to plant roots and reinvent themselves, to value tradition and spark innovation, to launch a business and form lasting bonds. It's an ideal place to open and operate a brewery or frequent one. Kansas City's brewers have a valued place in this community of fellowship, where beer invites social exchange and the way forward remains to be seen.

Bibliography

Books and Publications

American Bottler 32, no. 1 (1912).

American Brewers' Review 29 (1915).

American Catholic Historical Association. *The Catholic Historical Review.* Vol. 3. Washington, D.C.: Catholic University of America Press, 1918.

Baron, Stanley. *Brewed in America: A History of Beer & Ale in the U.S.* Boston: Little, Brown & Co., 1962.

Barry, Louise. *The Beginning of the West: Annals of the Kansas Gateway to the American West, 1540–1854.* Topeka: Kansas State Historical Society, 1972.

The Brewers' Hand-Book and Buyers Guide for 1918. Chicago: H.S. Rich & Co., 1918.

Brown, Ian. *The Economies of Africa and Asia in the Inter-war Depression.* London: Routledge, 2014.

Brown, John W. *Missouri Legends: Famous People from the Show-Me State.* St. Louis, MO: Reedy Press, 2008.

Bushnell, Michael. "Circus Grounds and Beer." *Northeast News* (Kansas City, MO), May 16, 2012.

Case, Theodore Spencer. *History of Kansas City, Missouri: With Illustrations and Biographical Sketches of Some of Its Prominent Men and Pioneers.* Kansas City, MO: Brookhaven Press, 1888.

Crutchfield, James A., Candy Moutlon and Terry Del Bene. *The Settlement of America: An Encyclopedia of Westward Expansion from Jamestown to the Closing of the Frontier.* New York: Routledge, 2015.

DeAngelo, Dory. *KC Life Downtown* (Kansas City, MO), May 4, 1988.

Dulin, Pete. *KC Ale Trail.* Kansas City, MO: Supon Publishing, 2012.

Everly, Steve. "Beer Maker Closes." *Kansas City Star,* June 22, 1999.

"Grubel Bottling Works, George." *Insurance Press* (New York) 34, no. 853 (1912).

Haley, Jean. "Muehlebach Pilsener Beer: A Kansas City Memory." *Kansas City Times,* July 7, 1972.

Hartmann, Rudolph H. *The Kansas City Investigation: Pendergast's Downfall 1938–1939.* Columbia: University of Missouri Press, 1999.

Hendricks, Mike. "Old-Is-New Brew Awakens KC's Tastebuds and Heritage." *Kansas City Star,* September 15, 2008.

Herbst, Henry. *St. Louis Brews: 200 Years of Brewing in St. Louis, 1809–2009.* St. Louis, MO: Reedy Press, LLC, 2009.

The History of Jackson County, Missouri. Kansas City, MO: Union Historical Company, 1881.

Kansas City: Its Resources and Their Development. A Souvenir of the Kansas City Times. Kansas City, MO: *Kansas City Times,* 1890.

Kansas City Journal. "A $200,000 Brewery: George E. Schraubstadter, of Galveston, the Principal Projector of the Enterprise." November, 15, 1899.

The Kansas City Manufacturer: A Journal Devoted to the Manufacturing Interests of Kansas City 4, no. 5 (February 1902).

Kioius, Kevin, and Donald Roussin. "Heim Brewery," *American Breweriana Journal* 103 (March–April 2000).

Kirkman, Paul. *The Battle of Westport: Missouri's Great Confederate Raid.* Charleston, SC: The History Press, 2011.

Lang, Michael. "Don't Forget the Microbrews." *Kansas City Star,* September 26, 2003.

Lippert, Leanna. "Top Five Historical Kansas City Breweries." *University News* (Kansas City, MO), March 1, 2010.

Mann, Jennifer. "Pony Express Rides Again." *Kansas City Star,* November 29, 2003.

Matson, Madeline. *Food in Missouri: A Cultural Stew.* Columbia: University of Missouri Press, 1994.

Maxwell, H. James, and Bob Sullivan Jr. *Hometown Beer: A History of Kansas City's Breweries.* Kansas City, MO: Omega Innovative Marketing, 1999.

Milwaukee Journal. "Schlitz Purchases Muehlebach Firm." June 28, 1956.

The Missouri State Gazetteer and Business Directory. St. Louis, MO: Sutherland & McEvoy, 1860.

Missouri: The WPA Guide to the "Show Me" State. Introduction by Walter A. Schroeder and Howard W. Marshall. St. Louis: Missouri Historical Society Press, 1941.

Moyer, David G. *American Breweries of the Past.* Bloomington, IL: AuthorHouse, 2009.

Poplinger, Megan. "Brewmaster." *Lawrence (KS) Journal-World,* October 25, 1995.

Public Affairs Information Service Bulletin 3. Public Affairs Information Service, H.W. Wilson, 1917.

"Report of Hearings on H.R. 17530, to Prevent the Manufacture and Sale of Alcoholic Drinks in the District of Columbia." United States Congress, House Committee on the District of Columbia, 1908.

Shortridge, James R. *Kansas City and How It Grew, 1822–2011.* Lawrence: University Press of Kansas, 2012.

Spalding, C.C. *Annals of the City of Kansas and the Great Western Plains.* Kansas City, MO: Van Horn & Abeel, 1858.

Wahl, Robert, and Arnold Spencer Wahl. *American Brewers' Review* 17 (1903); 27 (July 1913).

The Western Brewer Journal 41, no. 1 (1913); 45, no. 1 (1915).

Westport Improvement Association. *Westport, 1812–1912.* Kansas City, MO: Press of Franklin Hudson Publishing Company, 1912.

Whitney, Carrie Westlake. *Kansas City, Missouri: Its History and Its People, 1800–1908.* Chicago: S.J. Clarke Publishing Company, 1908.

Worthington, George, ed. *Electrical Review* 30–31 (February 10, 1897).

Websites

The Associated Press. "Executive Pleads Guilty to Taking $150 Million from J.C. Nichols Co." October 4, 2001. cjonline.com/stories/100401/usw_nicholscase.shtml.

BeerHistory.com. "A Driving Tour of Kansas City's Historic Breweries." beerhistory.com/library/holdings/kcdrivingtour.shtml.

Bender, Jonathan. "Tamale Wizard Is Now Open in the River Market." *The Pitch,* November 11, 2011. pitch.com/food-drink/article/20571991/tamale-wizard-is-now-open-in-the-river-market.

The Bottle Library. brucemobley.com/beerbottlelibrary/mo/index.htm.

Ciccateri, Tom. "Review of Dave's Brewpub." realbeer.com/nmvbp/revdaves.htm.

———. "Review of High Noon Saloon." realbeer.com/nmvbp/highnoon.htm.

City of Kansas City, MO. "Kansas City History." kcmo.gov/kansas-city-history.

The Civil War in Missouri. "Kansas-Nebraska Act: Bleeding Kansas." civilwarmo.org/educators/resources/info-sheets/kansas-nebraska-act-bleeding-kansas.

Curtin, Jack. "Philly Brews: Past Is Prologue." jackcurtin.com/liquiddiet/prologue.htm.

Dornbrook, James. "Boulevard Brewing, McCoy's Public House Medal at Beer Festival." *Kansas City Business Journal*, October 3, 2011. bizjournals.com/kansascity/news/2011/10/03/boulevard-brewing-mccoys-public-beer.html.

———. "A History of Boulevard Brewing." *Kansas City Business Journal*, October 17, 2013. bizjournals.com/kansascity/news/2013/10/17/boulevard-brewing-company-history.html.

Evans, Kara. "Devastation and Controversy: A History of Floods in the West Bottoms." Kansas City Public Library, August 11, 2014. kclibrary.org/blog/kc-unbound/devastation-and-controversy-history-floods-west-bottoms.

Fagan, Mark. "Burned." *Lawrence Journal-World*, January 9, 1996. ljworld.com/news/1996/jan/09/burned.

Frederick, Austin. "History of the Blatz Brewing Company." austinfrederick.wordpress.com/2012/08/08/history-of-the-blatz-brewing-company.

"From DNA to Beer." National Institutes of Health, U.S. National Library of Medicine, Bethesda, MD. nlm.nih.gov/exhibition/fromdnatobeer/exhibition-brewing-mysteries.html.

Gish, Sarah. "Crane Brewing of Raytown Goes Beyond the Pale Ale." *Kansas City Star*, January 26, 2016. kansascity.com/living/food-drink/article56467573.html.

Glass Bottle Marks. glassbottlemarks.com.

Griffin, Michael Englebert. Shaw Hofstra + Associates, Inc. National Register of Historic Places Registration Form. Imperial Brewing Company. January 31, 2010. dnr.mo.gov/shpo/nps-nr/11000011.pdf.

Hollar, Katie. "Slow Sales Send Pony Express Brewing Riding into the Sunset." *Kansas City Business Journal*, May 26, 2002. bizjournals.com/kansascity/stories/2002/05/27/story5.html.

Hudnall, David. "In the East Bottoms, John McDonald Sets Out to Brew the Future." *The Pitch*, August 4, 2015. pitch.com/kansascity/in-the-east-bottoms-john-mcdonald-sets-out-to-brew-the-future/Content?oid=5377543.

Jackson County Historical Society. jchs.org.

Kansas City Journal of Commerce. "Brewing and Distilling: Statistics of the Business in This City." February 26, 1870. vintagekansascity.com/kchistory/brewinganddistilling.html.

Kansas Historical Society. "Indian Removal Act." February 2011. kshs.org/kansapedia/indian-removal-act/16714.

———. "Isaac McCoy Papers." kshs.org/p/isaac-mccoy-papers/14076.

———. "Prohibition." kshs.org/kansapedia/prohibition/14523.

Kendall, Justin. "Boulevard Beer in Aluminum, New Breweries and More from the Year in Beer." *The Pitch*, December 29, 2015. pitch.com/food-drink/article/20560870/boulevard-beer-in-aluminum-new-breweries-and-more-from-the-year-in-beer.

———. "Brewery Emperial Plans to Join the East Crossroads Brewery Boom." *The Pitch*, March 24, 2015. pitch.com/FastPitch/archives/2015/03/24/brewery-emperial-plans-to-join-the-east-crossroads-brewery-boom.

———. "Cinder Block Brewery Adds an Event Space and a Patio, and Prepares to Can and Bottle Its Beers." *The Pitch*, July 29, 2015. pitch.com/FastPitch/archives/2015/07/29/cinder-block-brewery-adds-an-event-space-and-a-patio-and-prepares-to-can-and-bottle-its-beers.

———. "Michael Crane Takes his Homebrews on the Festival Circuit." *The Pitch*, May 14, 2014. pitch.com/FastPitch/archives/2014/05/14/michael-crane-takes-his-homebrews-on-the-festival-circuit

Koger, Chris. "Offer Made at Brewery." *Lawrence Journal-World*, February 12, 1997. ljworld.com/news/1997/feb/12/offer_made_at_brewery.

Margolies, Dan, and Amy Trollinger. "PB&J Appointed to Manage Bayou." *Kansas City Business Journal*, January 19, 1997. bizjournals.com/kansascity/stories/1997/01/20/story5.html.

Missouri Digital Heritage. "Gaudenzion S. Raffaletti." *Missouri's Union Provost Marshal Papers: 1861–1866.* mdh.deepwebaccess.com/mdh.

Missouri Valley Special Collections. kchistory.org.

Montgomery, Rick. "Foreword on the Civil War in Kansas City." Civil War on the Western Border: The Missouri-Kansas Conflict, 1854–1865. Kansas City Public Library. civilwaronthewesternborder.org/essay/foreword-civil-war-kansas-city.

Morris, Owen. "Restaurant Closing: River Market Brewery." *The Pitch*, February 3, 2009. pitch.com/FastPitch/archives/2009/02/03/restaurant-closing-river-market-brewery.

National Frontiers Trails Museum, Independence, MO. ci.independence.mo.us/nftm.

Nichols Co., J.C. Registration of Securities (General Form), Form 10, :10-12G: on 9/30/96—EX-99.1. secinfo.com/dRqWm.9w2d.k.htm.

Olathe, Kansas. "Street Names in Olathe." olatheks.org/FactsHistDemo/StreetNames.

Parkman, Francis, Jr. *The Oregon Trail.* gutenberg.org/files/1015/1015-h/1015-h.htm.

PBS. "The Panic of 1873." pbs.org/wgbh/americanexperience/features/general-article/grant-panic.

Pierce, Bill. "The House of Heileman." Brew Your Own, July–August 2012. byo.com/mead/item/2503-the-house-of-heileman.

Poland, Lathe. "The River Market Brewing Company in Kansas City, MO." Beer Tools. beertools.com/html/articles.php?view=136.

Ray, Mildred. "Postcard of East View from City Point." *Kansas City Star,* December 10, 1977. kchistory.org.

———. "Postcard of Heim's Electric Park in the East Bottoms." *Kansas City Times,* June 20, 1973. kchistory.org.

Reilly, Michael R. "The Wisconsin Glass Industry." March 22, 2009. William Franzen & Son, Milwaukee, Wis., 1900–29. slahs.org/antiqibles/glass_bottles.htm.

Rosin, Elizabeth, and Rachel Nugent. Rosin Preservation, LLC. National Register of Historic Places Registration Form, Old Town Historic District. dnr.mo.gov/shpo/nps-nr/11001019.pdf.

Stack, Martin H. "A Concise History of America's Brewing Industry." Economic History. eh.net/encyclopedia/a-concise-history-of-americas-brewing-industry.

The State Historical Society of Missouri. shs.umsystem.edu/manuscripts/descriptions/desc-photo.html.

———. statehistoricalsocietyofmissouri.org.

UW–Madison Libraries, Digital Collections. "Finding Aid of the Blatz Brewing Company Records, 1862–1944." digicoll.library.wisc.edu.

Weslander, Eric. "Suspect in Brewery Scandal Skips Town—Again." *Lawrence Journal-World,* October 2, 2004. ljworld.com/news/2004/oct/02/suspect_in_brewery.

Westport Historical Society. westporthistorical.com.

WestportKC.com. westportkc.com/history.

Index

Johnson, R.D. 87
Jordan, John 79
Joseph Schlitz Brewing Company 34, 40

K

Kansas City Bier Company 111
Kansas City Bottling Company 55
Kansas City Breweries Company 47, 58
Kansas City Brewery 25
Kasyjanski, Rich 125
KC Hopps, Ltd. 66, 75, 82, 83, 92
Kelly, Kyle 78
Kelly, Payton 71
Kerzner, Ray 127
Kumpf, Frank Hubbard 35
Kunz, August 22

L

Lenhard, John 27
Lion Brewing & Bottling 59
Lueders, Jim 79

M

Mack, George 22
Magerl, Chuck 46, 129
Main Street Brewery 30
Mankind Brewing Company 100
Martens, Eric 119
Martin City Brewing Company 100, 102
Mason, Benjamin 30
McCoy, John Calvin 92
McCoy's Public House 92
McDonald, John 52, 61, 78, 129

Messerschmitt, George 28
Meyers, Christopher 117
Midwest Brewing Company 60
Mill Creek Brewery and Restaurant 78
M.K. Goetz Brewing Company 43
Moore, Matt 102
Moore, Travis 114
Muehlebach, George 31
Muehlebach, George E. 32
Muehlschuster and Sons Brewery 29
Muehlschuster, Michael 29

O

Ogilvie, Aaron 121
Overland Brewing Company 86

P

Pabst Brewing Company 39
Pacific Brewery 28
Palmer, Steve 81, 96
Parish, William 27
Pasteur, Louis 37
Pauwels, Steven 64
Payne, Stacey 83, 99
Pendergast, "Boss" Tom 38, 39
Pickett, Joe 84
Pony Express Brewing Company 83, 89, 99
Power Plant Restaurant and Brewery 81, 96
Prohibition 22, 38, 39, 46, 52
P. Setzler & Sons 55
Ptacek, Michael 104

R

Raffaletti, Gaudenzion S. 27, 28
Ragonese, Jeremy 63
Red Crow Brewing Company 122
Ripple Glass 72
River Market Brewing Company 23, 81, 96
Roberts, Chris and Mistie 122
Rochester Brewing Company 51, 54, 56
Rock & Run Brewery and Pub 109
Root Sellers Brewing Company 25

S

Saddle Sore Brewing Company 77
Salah, Allen 86, 90
Saleh, Nabil 86, 90
Sandman, Pat 124
San Miguel Corporation 34
Schaffter, Bryce 107
Schiller Bros. Brewing 59
Schraubstadter, George E. 56
Schwitzgebel, Peter John 25
Setzler, Philip 55
75th Street Brewery 75, 83, 91, 93, 100, 101, 124, 125
Soriano, Andres 35
Sports Page Brewery 86, 90
Star Ale Brewery 35
Stewart, Bryan 121
Stinson, Glen 124
Stockyards Brewing Company 127
Strange, Randy 118
Swedish Ale Manufacturing Company 59

T

Tafoya, Artie 82
temperance movement 45
Third Street Brewery 25
Thoma, Leo 56
Thompson, Julie 125
Thompson, Keith 93, 125
Torn Label Brewing Company 114
23rd Street Brewery 91, 108

V

Valentin Blatz Brewing Company 39
Vaughn, Nick 100, 102

W

Walruff, John 22
Weichert, Micah 101, 128
Weinfurt, Corey 23
Weiss Beer Brewery 56, 59
Werkowitch, Bob 70
Western Brewery 28
Weston Brewing Company 22, 85, 89
Westphal, James 92
Westport Brewing Company 77
Wettest Block in the World, the 45
Wilderness Brewing Company 101
Witte, Neil 66, 78
Wolfkule, Hermann 28
Wolf, Leo 31, 60

Y

Yeager, Emily 93

About the Author

Pete Dulin has written about food, beverage and other subjects for more than fifteen years. His work has appeared in *Feast Magazine*, *Recommended Daily*, *Flatland*, the *Kansas City Star*, *Visit KC*, the *Boston Globe* and many other publications and websites. He is the author of *KC Ale Trail*, *Last Bite: 100 Simple Recipes from Kansas City's Best Chefs and Cooks* and the forthcoming *Expedition of Thirst*. He lives in Kansas City, Missouri.

Photograph by Paul Andrews Photography.